~IMAGINARY~
CHARACTERS

Mixed-Media Painting Techniques for Figures & Faces

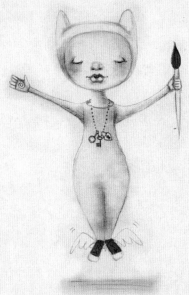

KAREN O'BRIEN

NORTH LIGHT BOOKS
CINCINNATI, OHIO
www.createmixedmedia.com

TABLE OF CONTENTS

CHAPTER 1

Fantastical Worlds of Collage:

Creating Enchanting Realms and Characters

14

CHAPTER 2

Drawn From Your Imagination:

Approaches to Discover Your Unique Drawing Style

40

CHAPTER 3

Mystifying Pictures:

Characters Rising From Ink and Paint

74

CHAPTER 4

Happy Endings and Beginnings:

Continuing the Creative Quest

116

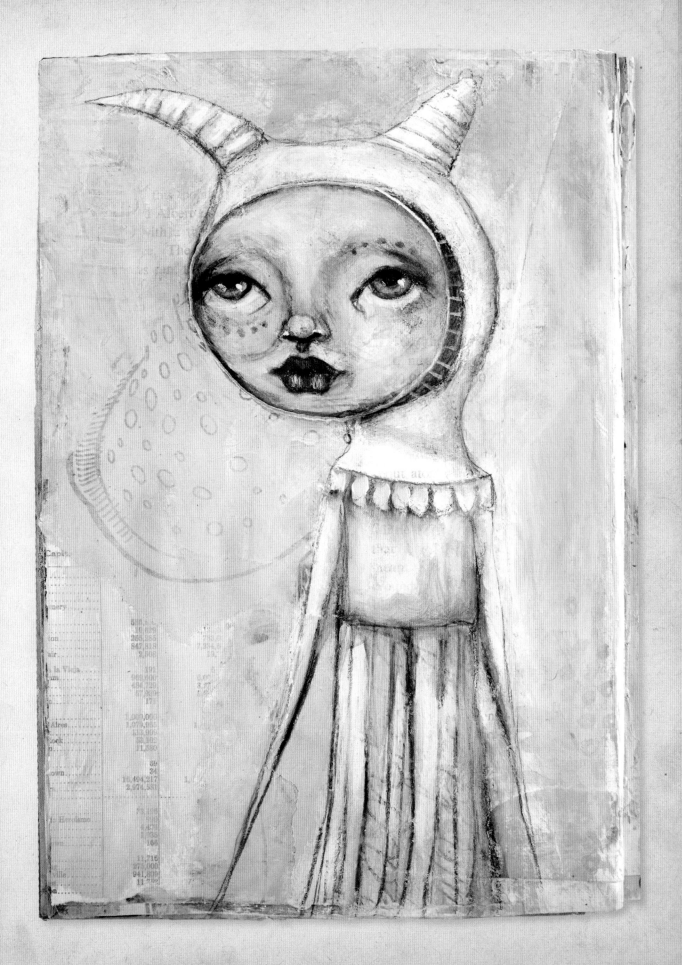

INTRODUCTION

In folktales, curiosity is a trait that can get a girl in a lot of trouble. That thought has never dampened my enthusiasm for playing, taking risks and asking "what if?" There is a close link between curiosity and creativity. I see it as a circle: If you are curious and allow yourself to play, then the more you discover and the more creative you get by solving problems. This leads back to curiosity again and then back to play.

My approach to art is to let go of expectations, to dive in and see what happens. This is how I am teaching myself to make better art. I am on a quest, seeking something that sparks my creativity and keeps me coming back to the studio. I am searching for information that will make my art better, more unique and more fun to do.

Each time I buy a new book on art techniques, I am weak with anticipation over the possibilities within the pages. I am not alone in this quest for inspiration and a fresh or unusual approach to creating art; you are probably right there with me. We are a community of questers, those in search of the magic that comes from creating something from your heart. We are also a community of storytellers. We tell our stories through words and pictures every day. We use social media, take pictures, share special moments online, interact with others during the course of the day. We notice the smell of the ocean, a little girl with red sneakers and the sound of wind in the trees.

Each little fragment of information is a source of inspiration and a potential story unfolding. These fragments are part of what I call my "urban landscape," a fusion of what I observe, dream and imagine every day. I nurture this landscape by collecting these scraps of ideas. I write things down, take pictures and add them to my sketchbook. Most important, I try to be present and notice as much as I can, recording the ideas in my memory, so they'll be ready to spill out into my art.

Chapter Keys

Our Tale: Each chapter has a new section of story. Follow along with the tale of the girl in the red shoes as she learns new skills and tries exciting new mixed-media projects.

Chapter Treasure: At the beginning of each chapter, you'll find a list of treasures. These are the things you'll learn while exploring and creating the projects in the chapter.

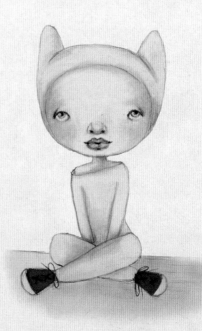

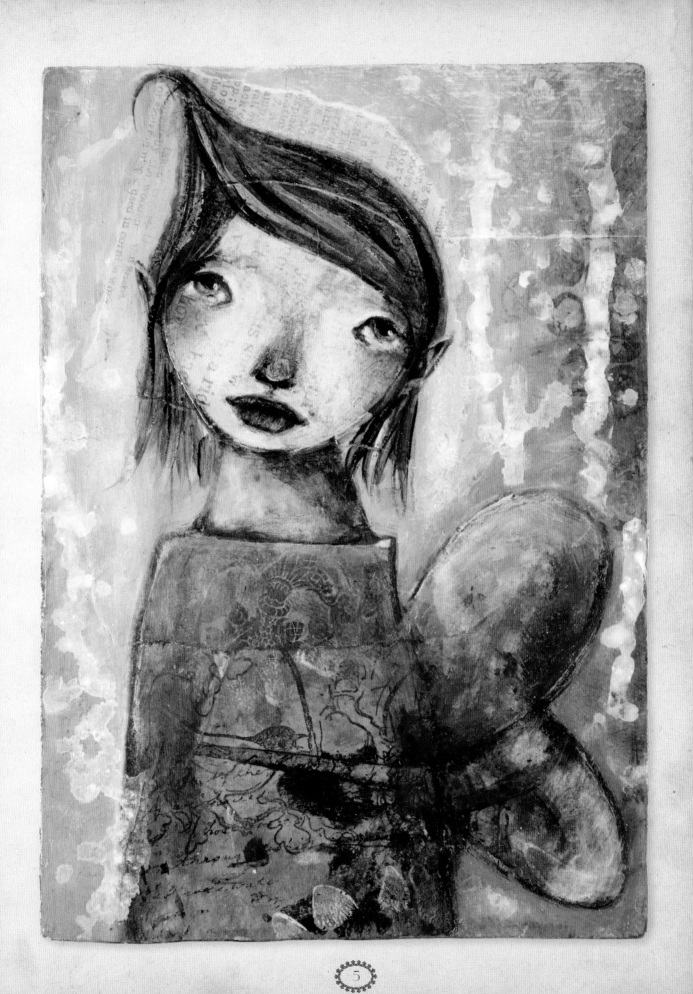

OUR TALE BEGINS

There once was a girl with red shoes who lived in a small village. Red shoes are known to have special powers, and these were no different. She wore her shoes to bed, and she dreamed of making things with her hands and using her creativity every day. Her head was filled with thoughts of magical landscapes, creatures, heroes and heroines. Sometimes she felt as if she would burst if she could not make the characters from her imagination come to life. This girl loved her crayons and drew outside the lines in her books, making colorful worlds with pink skies and blue trees. She was told that she needed to follow the rules, to stay in the lines and to color her trees in hues other than blue. Others made fun of her unusual choices and her creative voice started to fade.

One night an enchanted butterfly visited her in her dreams and left a magic key on her pillow. Attached to the key was a tag that said BE CURIOUS! Upon awakening, the girl went to see the village storyteller. The storyteller said, "It is a sign that you are ready to go out in the world and find your unique creative voice. All you need to do is wear your magic shoes to bed, and they will take you where you need to go in your dreams." So the girl put the key on a chain around her neck and began planning for her journey of discovery.

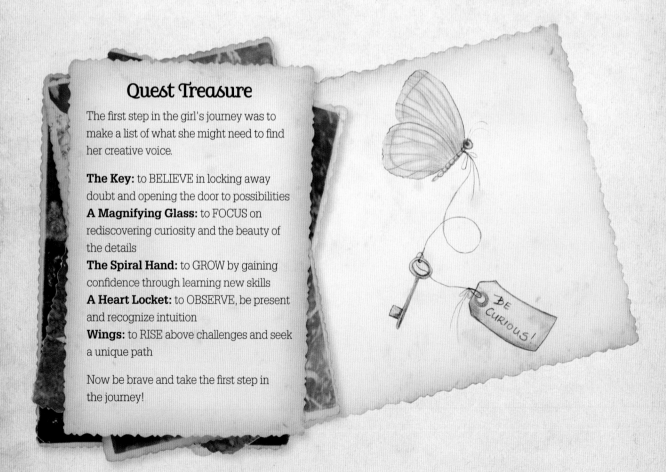

Quest Treasure

The first step in the girl's journey was to make a list of what she might need to find her creative voice.

The Key: to BELIEVE in locking away doubt and opening the door to possibilities
A Magnifying Glass: to FOCUS on rediscovering curiosity and the beauty of the details
The Spiral Hand: to GROW by gaining confidence through learning new skills
A Heart Locket: to OBSERVE, be present and recognize intuition
Wings: to RISE above challenges and seek a unique path

Now be brave and take the first step in the journey!

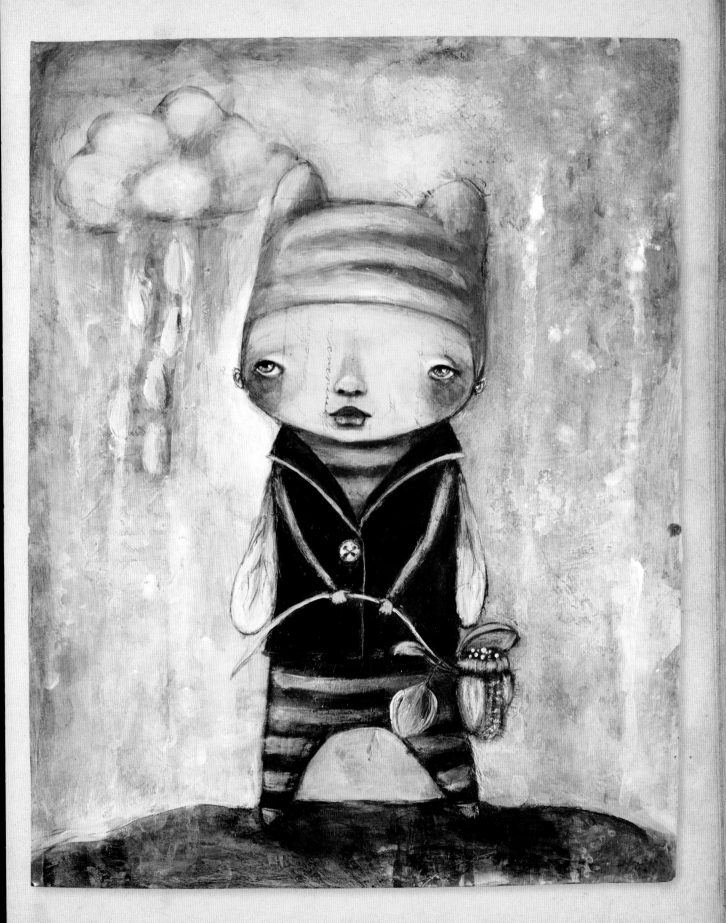

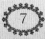

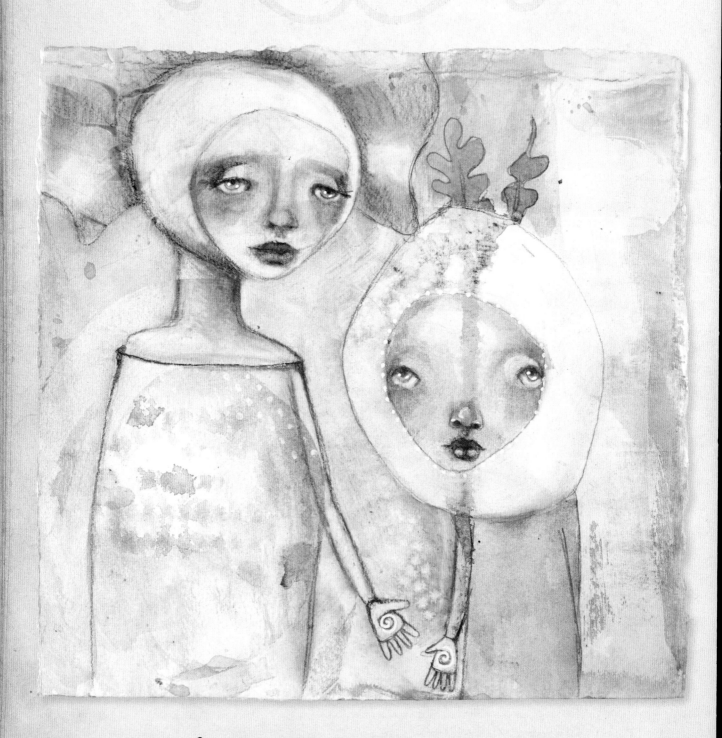

Visit createmixedmedia.com/
imaginary-characters to discover bonus art

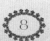

BEGINNING THE QUEST: PACKING LIGHT

Our quest begins the way most journeys do: We gather and pack. I challenge you to begin with materials you are most comfortable with and have on hand. When you are considering your ingredients, ask yourself three magical questions:

>> What are you seeking? Are you looking for relaxation, play and a little flexing of your creative muscles? Inexpensive supplies may be more approachable. If you want to splurge, I recommend treating yourself to a few artist-grade paints.

>> What will you do with your art when it is completed? The answer to this question will play a part in determining the supplies you choose to make a piece. You may be making art for yourself, giving it as gifts or perhaps selling it. If you plan to keep your art, working in an art journal allows for lots of creativity without storage issues. If you are going to gift or sell your art, consider the surfaces you choose. What will be required to assemble your finished product? Will it withstand the rigors of transporting, displaying and storing?

>> If you were setting out on a long journey and could only take what you could carry easily, what would you bring? My rule is that travel supplies should fit in a gallon-size self-sealing bag. If a supply does not fit, it stays home. A small bag and a sketchbook are all you need to capture new experiences on the road. I will reveal my essential travel supplies, which really do fit in a gallon-size bag, in chapter 4.

Our Tale Continues

The next night the girl went to bed with her red shoes on and dreamed of a giant tree with a door at its base. She found the door unlocked and opened it to find a box with a lock that fit her key. Inside was a message that said, "Put your self-doubts and inner critic in this box and lock it. Bring the box on your journey to hold the magical treasures you uncover on your quest."

When you turn the page, you will be stepping through a door that leads to your individual path. Your quest to find your unique creative voice will begin. You have your magic shoes; the door is open. It is time to gather and pack.

GATHERING MAGICAL
TOOLS AND MATERIALS

Surfaces

I prefer a smooth, solid surface to work on. That way I can control how much texture is added and where I add it. My favorites are 140-lb. (300gsm) hot-pressed watercolor paper, Bristol paper, red rosin paper, wood, unstretched canvas and deli paper.

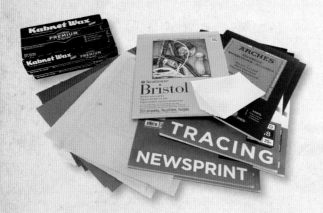

Paint Applicators

I use a variety of brushes. Most are fairly inexpensive since I am really hard on them. My favorites are a ¾–1" (19mm–3cm) flat nylon brush and a few round detail brushes. I use a small selection of specialty tools, including cheap hog hair chip brushes, a fan brush for texture and a mop brush for holding lots of juicy paint. A recycled plastic card or paint scraper is essential to push paint around and smooth out collage. For travel, I carry a

Niji Waterbrush, which is a combination brush and water container.

Mediums and Glues

White glue products can create a film that resists paint applications. Acrylic mediums are formulated to mix with acrylic paint. Because of this, acrylic mediums are my primary adhesive for collage and fabric. Acrylic mediums range in consistency from pourable to moldable and have varying finishes and levels of transparency. Here are my studio staples:

Fluid Matte Medium: This is a pourable liquid medium for gluing collage and blending with acrylic paints and inks. It can decrease the intensity of a color and extend the working time of acrylic paint. I use matte medium instead of water to blend my watercolor pencils and gouache paint. The medium sets the watercolor, preventing it from reactivating once it is dry.

Golden Soft Gel Medium Matte: Golden is the only brand I have found with the consistency that runs between a liquid and regular gel medium. It works as a glue for heavier collage papers and fabric, and dries to a matte finish. It is my preferred medium for gel medium transfers.

Regular Gel Medium Gloss: Thick in consistency, similar to heavy body paint, it can be used for gluing heavier items and applying to a surface for texture. Because the gloss finish dries completely transparent, it works well for gluing packing tape transfers and transparencies.

Glue Stick: Fast and less messy than using mediums, a glue stick works well for attaching small items and assembling lots of small parts. I pack one in my travel kit for adding collage items to my sketchbook.

Golden Acrylic Absorbent Ground: This clay-based medium allows nonabsorbent surfaces to accept watercolor and pencil. I use it in my journals. It magically transforms random collage into a dreamy watercolor surface. Both Golden and Daniel Smith make a watercolor ground that works in a similar way.

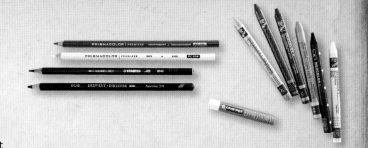

Clear Gesso: This is a white medium that dries clear with a rough surface. I use it sparingly in areas where the surface is too slick to get good coverage with my colored pencils.

White Gesso: A white painting ground, this gesso seals and adds tooth to the surface. It can be used as a first layer on watercolor paper and will prevent acrylic paint from being absorbed unevenly while allowing the paint to flow over the surface. Painting gesso on texture items and stamping the surface can create a resist when it dries.

Self-Leveling Clear Gel: This product provides a transparent, high-gloss finish that can be poured onto a surface, eliminating brushstrokes. I use it over packing tape transfers to hide the edges of the tape.

Isopropyl Alcohol: Alcohol acts as a resist and repels the wet paint, creating interesting blooming patterns on the surface. It can be added directly to a painted surface or applied with a cloth to remove a layer of paint through a stencil. It comes in varying concentrations from 70 to 99 percent.

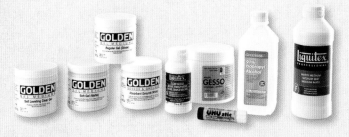

Mark Making

Waterproof Pens: Sharpie Permanent Markers and Faber-Castell PITT Artist Pens are both waterproof. Test any marker with water before adding it to your project. I like the fact that I can buy a Sharpie marker almost anywhere.

Paint Pens: Sharpie Fine Point Water-Based Paint Markers are my favorite. They work on any surface and do not have an odor. I limit myself to white, black and red.

Colored Pencils: These have a creamy, waxy consistency that comes in many colors. I use them to color images, make marks and write. White and buff pencils can be used to blend colors. Prismacolor Pencils are my preferred brand because of the range of colors offered and their smooth application.

Water Resistant Crayons: Caran d'Ache Neocolor I are wax pastels that make permanent marks and resist water applications. Cray-Pas Oil Pastels are inexpensive, creamy and make bold marks on just about any surface. You can smear them with your fingers for a ghost effect. The advantage to using these brands is that you can order them individually.

Watercolor Pencils: Derwent Inktense Pencil colors are bolder in application than most brands. I use them for drawing and adding extra color in small areas.

Graphite Pencils: The numbers on graphite pencils represent the levels of hardness (H) and blackness (B) of each. Example: 9H is the hardest, lightest line; 9B is the softest, darkest line. The two pencils that fit most of my needs are a No. 2 mechanical pencil with an eraser and a 6B graphite pencil.

Blending Stumps: This is a paper stick made to blend graphite pencils. The sticks can get into small areas and save your fingers from becoming coated with graphite. They can be cleaned and sharpened with a small piece of sandpaper, and they come in various sizes.

Erasers: I use a stick-style eraser for my pencil drawings. It allows me to erase small areas, like the highlight of an eye, fairly accurately. Kneaded erasers work well for cleaning up larger areas.

Rubber Stamps: I prefer un-mounted stamps so I can put them in water after use. I stay away from recognizable images, using mostly text and texture stamps. I use a thick application of watercolor paint on the stamps to add subtle visual texture. If I am using ink, I keep it simple and use

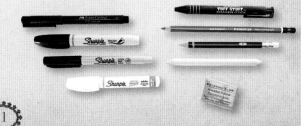

only black. Versifine and StazOn Ink Pads are quick drying and will not smear.

Foam Stamps: These stamps are sold in craft stores. They are ideal for stamping patterns using acrylic paints. Just apply the paint to the stamp using a brush and press the stamp onto the surface. Place your stamps in water until you are ready to clean them.

Stencils: I like to add texture to surfaces by applying gel medium through a stencil with a palette knife. Stencils are also great for subtracting a layer of paint using water or isopropyl alcohol.

Texture Stamps: Stamping with common household items that have texture (like shelf liner, cardboard and jar lids) adds surface interest and is virtually free!

Texture Tools: Use these to carve into wet paint and mediums. Bamboo skewers, combs or the end of your brush create unique interest and texture, and the resulting marks provide a place for paint and glazes to pool.

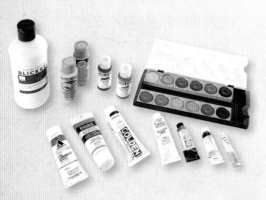

Paint

Acrylic Paint: This paint is available in many forms and a variety of price ranges. The amount and quality of pigment usually determines the cost of the paint. I use everything from inexpensive to artist grade. In the early layers of my paintings, I use inexpensive Blickrylic Student Acrylics. The paint is nontoxic and allows me the freedom to use my hands if I choose. I use craft paint for my journals. It tends to be more matte in finish, preventing pages from sticking together. Artist-grade paints produce better color, coverage and control. My favorite brand of heavy body paint is Liquitex for its creamy consistency and easy-open tubes. Golden Fluid Acrylic paints are highly pigmented and fluid in consistency. Used as a glaze over collage, they can help unite different elements into a cohesive piece.

Watercolor: Watercolors also vary in their pigment levels. The more expensive the paint, the more vibrant the color. Pelikan makes affordable pan watercolor sets. For travel, I fill the empty pans of an old tin watercolor case with a selection of tube watercolors, which fit neatly in my kit.

Acrylic Ink: Acrylic ink behaves like fluid acrylic paint and is permanent once dry. It can also be watered down and used like watercolor. Daler-Rowney FW Acrylic Artist Ink is my favorite brand because it's consistently waterproof and comes in rich colors.

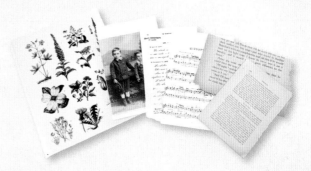

Collage

Paper: Look for old books with interesting text style and varying font sizes. Scan interesting pages into the computer, or photocopy them at the copy store where you can create various sizes using the enlarging function. Romance paperbacks, poetry books and Shakespearean plays are fun sources for interesting dialogue to add to collage pieces. Recycled security envelopes and inexpensive coloring book pages are an economical way to create graphic interest.

Images: I use copyright-free images in my artwork, but you can use anything you wish for art that you make for pleasure or that you give as gifts. I prefer to use black-and-white clip art for collage. It leaves my color choices open, and I can control the paper quality. I also love to use vintage images of children, which we will explore in greater depth in chapter 1.

Other Studio Staples

Baby Wipes: An essential studio and travel tool, baby wipes are great for everything from removing paint to cleaning my hands.

Tape: I use clear packing tape for image transfers and regular masking tape to repair torn pages in my journals.

MY PALETTE

I use two basic palettes. One palette serves as my primary mixing colors: Pyrrole Red, Hansa Yellow, Prussian Blue. The second palette is my primary muted mixing colors: Quinacridone Red, Yellow Ochre, Payne's Gray.

I prefer to mix the secondary colors of green, orange and purple from the basic palettes. This assures that the secondary colors I use will be in harmony with the other colors. Often I will vary my primary palette by substituting one of the muted colors for a primary color.

I use the same color palette for my watercolors, inks, colored pencils and watercolor pencils. The names vary by brand, but the colors are as close as I can get them. This simplifies my choices, and I can concentrate on the process without worrying about finding the "right" color.

I highly recommend purchasing a color wheel that also includes a basic gray scale. It is a great tool for learning about color. Play with the colors you have. Use your journal to experiment with color mixing red, blue and yellow. You will see what your colors can do and have a reference when you are painting.

The Color Wheel Made Simple

Primary: red, yellow, blue

Secondary: Created by mixing two primary colors together. green, orange, purple

Tertiary colors: The last six colors created by mixing primary and secondary colors. red-orange, yellow-orange, yellow-green, blue-green, blue-violet, red-violet

Color Schemes

Analogous: Colors next to each other on the wheel

Complementary: Colors opposite each other on the wheel.

Triadic: Combination of every fourth color on the twelve color wheel.

Warm: Energetic — sunlight (yellow, orange, red).

Cool: Calm — sky/shade light (green, blue, purple).

Avoiding Mud

Alternate layers of warm and cool colors, allowing them to dry in between to avoid muddy colors when mixing.

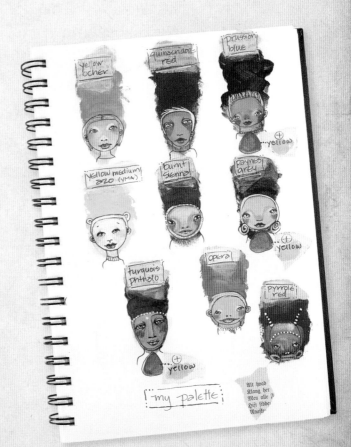

FANTASTICAL
WORLDS OF COLLAGE

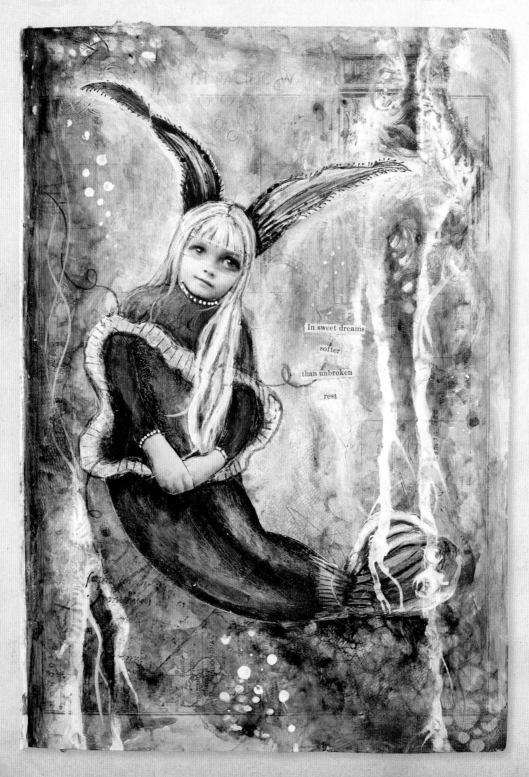

In sweet dreams

softer

than unbroken

rest

Creating Enchanting Realms and Characters

A folktale is a traditional story, usually time-less and placeless, without a known author. Folktales are rooted in cultural traditions. They serve as a way of making sense out of everyday life and the mysteries of the world. Traditionally folk-tales were not written down, but passed on by word of mouth. A storyteller used words to paint a picture in the listener's imagination. Each storyteller had the chance to embellish and mold the folktale, making it new each time it was told. Today *you* are the storyteller, with the chance to add elements in a way that is unique to you. Think about your talismans, your favorite places, smells, sounds and the repeating symbols in your life and art. My symbols include circles, spirals, hands, roots, anything related to the ocean, bears, deer and things with wings. Each of these are part of my personal visual language and have meaning to me.

A good place to begin our quest, and rekindle a playful approach to art, is with collage. Cutting and pasting to create a magical world full of blue trees and unreal creatures. Close your eyes and think back to childhood when blunt scissors, colored paper and that glue that smelled good enough to eat were the ingredients for hours of fun art play. When you consider a setting for your tale, what environments excite you? Are you looking for distant lands or castles? Realistic, abstract or magical elements? What kind of folks live in your setting? Magical beasts, beautiful princesses, talking animals?

The best way to seek your original voice is to be spontaneous—no planning! Be willing to feel discomfort in the process, while creating something that even you cannot repeat. Sound crazy? Let's give it a try.

Our Tale

On the first night of her journey, our heroine passed through a forest. Little snippets of stories were suspended from the trees like leaves. As she continued, she came upon the village of Curiosity, where everyone's favorite question was "What if?" She was greeted by the town librarian who gave her a magnifying glass and invited her to open her eyes to this magical place full of possibilities, to embrace play and see what happens.

Chapter Treasure

Focus.
Noticing the beauty of the details.
Rediscovering a sense of play and curiosity.
Creating enchanting realms and characters.

"I think, at a child's birth, if a mother could ask a fairy godmother to endow it with the most useful gift, that gift should be curiosity."

Eleanor Roosevelt

THIS IS MY LETTER TO THE WORLD

Uncover the Many-Layered Mystery
Deli Blotter Collage

This exercise is a constant source of wonder. Like a folktale that varies with each telling, it is basically impossible to replicate, despite using the same ingredients. The deli and blotter collages can become a beginning setting for your story, or sections of them can be used for other projects.

Having your materials ready to go will allow you to work quickly and spontaneously. The deli paper used in this exercise is a wax-like paper and can be found at stores that carry restaurant supplies. The paper is translucent, so you have the option to use the reverse side if it proves to be more interesting. If you cannot find deli paper, you can substitute any paper that can hold up to water media without buckling.

I use a piece of paper, designated as my "blotter," to transfer excess paint and unload my brushes, scrapers and stamps. I also collage any leftover papers onto the blotter afterward. A blotter allows me to continue to work without waiting as long for paint to dry. I am using Bristol paper in this exercise, but you could use any paper that can handle wet media.

Gather

¾" (19mm) flat brush
Acrylic craft paint
Bamboo skewer
Black-and-white clip art images and text
Bristol paper at least 7" × 10" (18cm × 25cm) for blotter
Deli paper
Foam stamp
Fluid matte medium
Gesso: white
Oil pastel
Permanent marking pen, wide tip: black
Plastic card or scraper
Texture stamps
Vintage book pages: 4" × 6" (10cm × 15cm)

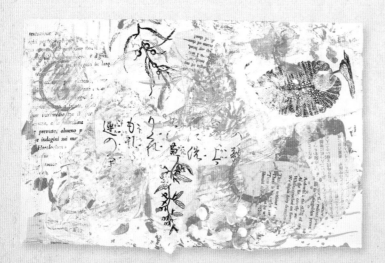

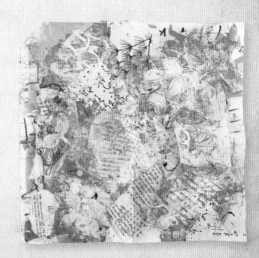

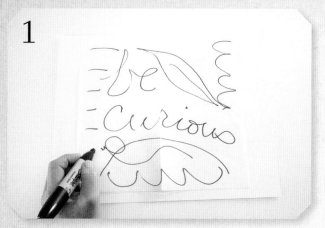

1

Write

Arrange torn book pages and clip art in a pile, and pour out pools of matte medium and each paint color before you begin. Cover both the deli and blotter papers with writing, using a permanent ink pen. Use text from a folktale or poem, or write your intention for this exercise. A variation on this step would be to use a colored pencil or crayon instead of a pen.

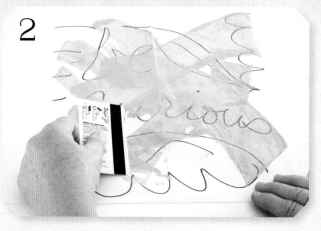

2

Paint

Select a paint color and pick up a small amount with a plastic card. Scrape the paint randomly over your writing, leaving some text showing. Scratch into the wet paint with the plastic card, making texture marks.

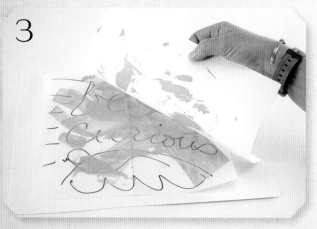

3

Blot

Lay the blotter paper over the deli sheet. Rub lightly and remove to pick up the excess paint.

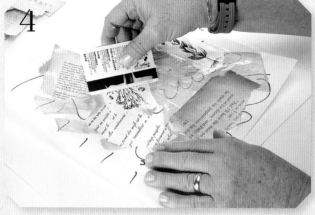

4

Add Collage Paper

Drop five pieces of collage randomly onto the deli surface, and glue them down using matte medium. Rotate the deli paper to give you a different perspective on the piece.

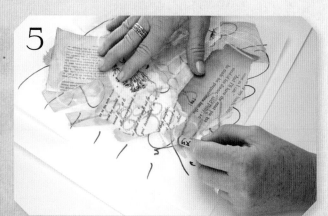

5

Add Crayons or Pastels

Make some random marks or doodles on the paper with an oil or wax pastel crayon. Be sure to go over some of the collage with your marks.

6

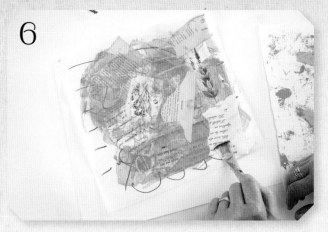

Repeat Steps

Select your second color and repeat steps 2–5. Blot with the blotter after each paint application.

Be more purposeful with your collage placement, adding to areas that are untouched, especially the edges of the paper. If the paint, marks and collage go all the way to the edges, you will have more unique collaged paper to choose from for later projects.

7

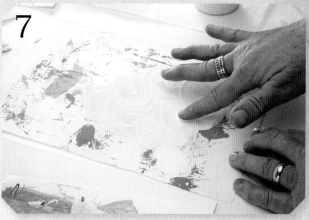

Gesso

Put a small amount of white gesso onto the blotter paper. Use your finger to draw designs into the paint. Spread the paint fairly thin.

8

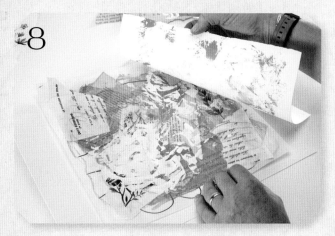

Mono Print

Lay the blotter paper, paint side down, over the deli paper and pull it up. Repeat printing until the paint is gone.

9

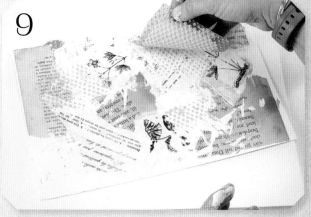

Texture Stamp

Apply paint to a texture stamp with a brush or finger, and stamp its design randomly onto the deli paper. Blot again with the blotter paper.

10

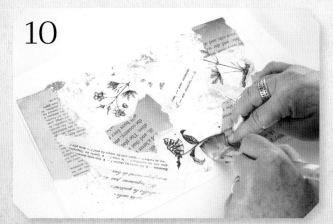

Finish the Blotter

Move to the blotter paper, and glue down the remainder of the collage papers, adding marks with oil or wax crayon. Repeat steps 7–9, this time working with the surface of the blotter paper to finish it.

DISCOVERING VALUE

In folktales you will see that the hero's path is rarely black-and-white, but littered with many choices in between. On our artistic path, too many choices can be overwhelming. Limiting your color selection is a wonderful way to give yourself more freedom to explore. You can't get more basic than using only black and white.

Black and white are the two extremes of the value scale. The value scale is a gradual movement of shade, from black to gray to white. When someone refers to "values" in a painting, they are looking at the range of shades from lightest to darkest. A varied range of values is needed to create drama in your art. Practicing with only black and white will help you learn to identify values and improve the dramatic impact of your art. Try

the Deli Blotter Collage exercise using only black, white and middle gray. Middle gray is halfway between white and black on the value scale and can be made by mixing equal parts black and white. Notice the range of values and contrast that are produced when you are done. If you have a digital camera, photograph your color Deli Blotter exercise and convert it to black and white. Compare the two exercises, noting the differences. You will probably notice that the color exercise is lacking darks. This is because most craft paint colors exist in the middle range of the value scale. Remember this next time you do the exercise in color. Adjust your choices and see what happens.

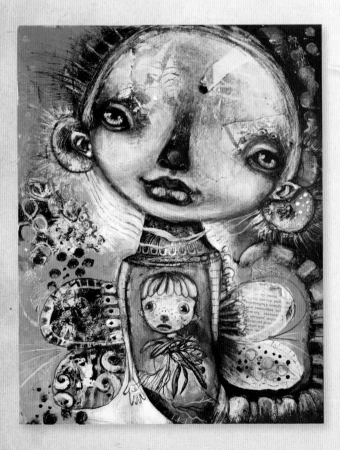

"I used to be Snow White, but I drifted."

Mae West

Obscuring and Glazing Techniques

White is a powerful color in folktales and in art. White wizards and snow queens are symbolic of purity and good. The white of a blank canvas or journal page can be seen as intimidating or as an opportunity. White is reflective and amplifies everything near it. It can calm areas that are distracting and brings light back into the piece. White is the one color I can't live without.

For this exercise, you will experience the power of using white on a complicated background. Look at your piece as a whole composition and identify areas that pull your eye or distract you. Those elements can be hidden completely with a heavy application of white or softened and pushed into the background by a thin blended layer of white. Use white to connect busy, random pieces of collage into larger areas and to break up rigid edges. Work the entire piece with this process until you are satisfied.

Once the white is completely dry, you will introduce glazing. A glaze is a layer of thin transparent color. Layers of color used on top of one another build depth. Glazing can unify your piece and create a many-layered, mysterious look that cannot be achieved by mixing and applying colors directly. The areas of added white will "glow" with the transparent color.

Gather

¾" (19mm) flat brush

Bamboo skewer or other texturing tool

Damp rag

Deli Blotter Collage exercise

Fluid matte medium

Foam stamp

Gesso: white

Golden Fluid Acrylic Paint: Transparent Red Iron Oxide, Transparent Yellow Iron Oxide

Heavy body acrylic paint: Titanium White

Glazing With Acrylics

Here are some tips to keep in mind when using fluid acrylics as a glaze.

» Mixing fluid acrylics with acrylic matte or gloss medium will increase the transparency of the color. This works especially well with darker colors.

» Clean your brush well between applications.

» Change your water frequently. Use one container for light and one for dark color rinsing.

» Allow each layer to dry before applying the next layer.

» Add water to a pool of paint, and drip or splatter it onto the surface.

» Try writing into wet paint or subtracting paint by laying down a stencil and wiping a damp rag over it.

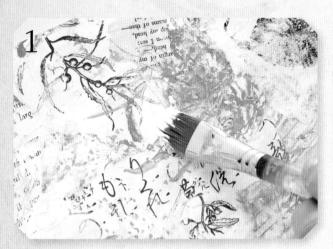

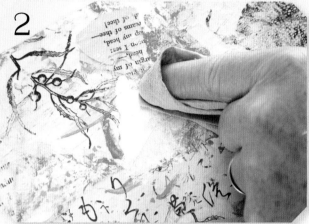

Add White

Grab one of the pieces you created in the Deli Blotter Collage exercise. Using a flat brush, apply Titanium White paint to the areas you want to minimize or eliminate. Connect areas of smaller collage pieces with white paint, making the surface less busy.

Blend the White

Feather and blend the edges of the white paint so they fade into the surrounding areas. Use a damp rag or your fingers.

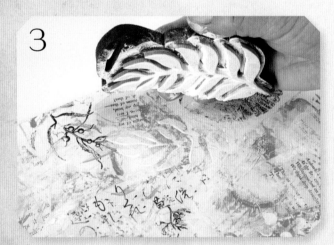

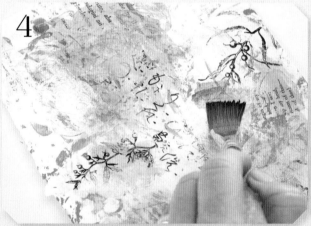

Add Stamps

Paint a stamp with white gesso and print on the paper. Create added texture by carving into wet gesso using texture tools or the end of your brush. Paint will pool into the texture marks, leaving a more interesting surface. The gesso will glow when the fluid acrylic is applied.

Start Glazing

Remove excess water from a wet brush by blotting it with a rag. Pick up the fluid acrylic paint with your damp brush and apply in thick and thin applications. Work randomly across the collage surface.

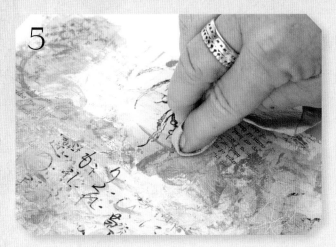

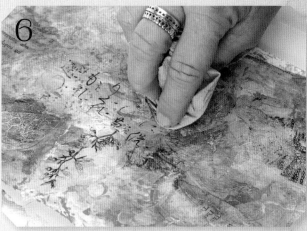

Blend the Glaze

Use a damp rag and varying pressure to blend the edges and move the glaze around for a randomized effect. You want to retain some variety, so don't overdo it. Let this layer dry completely.

Add More Color

Add a second color randomly on the surface with a brush and then blend in some places with a damp rag. Repeat this process with more color until you are satisfied with the results.

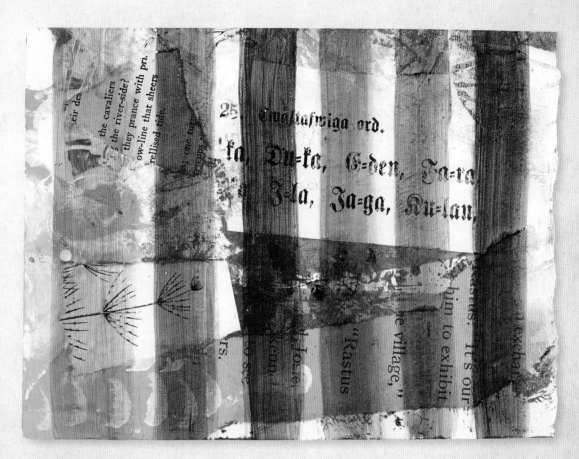

Layering Color

Layering provides depth to the color that cannot be achieved by mixing. The glazing color will be influenced by the colors used in the earlier layers. Notice the turquoise blue area in the background looks green when a yellow glaze is applied.

CURIOUS CONNECTIONS
Combining Unrelated Images to Make Whimsical Figures

There are three styles of photographs I collect and use in my art: tintypes, carte de visite (CDV) and cabinet cards. All three types of photographs were popular from the 1850s to the 1900s. Tintypes are photographs printed on a thin sheet of iron coated with a dark lacquer or enamel. CDV and cabinet cards are printed photographs mounted on a thick paper card. A CDV is usually 2½" × 4" (6cm × 10cm). The size of a Victorian calling card, they were popular for trading and collecting, much like modern artist trading cards (ATCs). The larger cabinet card (4½" × 6½" [11cm × 16cm]) was popular until the early twentieth century,

when Kodak introduced the Brownie camera. Home snapshot photography was born, and we never looked back. Vintage photographs of all kinds can be found in antique malls, flea markets and even garage sales.

The techniques in the following projects do not require using vintage photographs. Photographs from any era can be fun to reimagine. I recommend scanning the photographs you plan to use in your art. You will then be able to size the photos and choose the paper and printer type appropriate to your project.

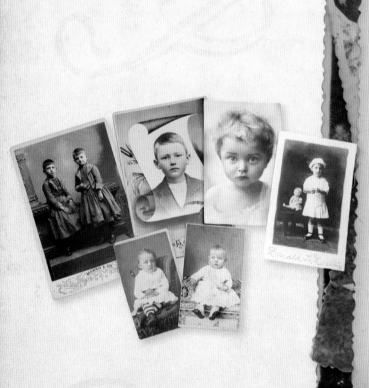

Printer Primer

I use both an ink-jet and laser printer in my studio. Some techniques work better using one printer over the other. Ink-jet printers place tiny drops of ink onto the paper or fabric surface. Images printed from most ink-jet printers will smear when wet media is applied. There are products that can be used to treat the paper to decrease smearing. Golden Digital Ground is a medium that is painted on the paper before putting it through the printer. Spray finishes called "workable fixatives" can be used on the paper after printing. I use an ink-jet printer for printing on photo paper and fabric.

For the exercises and projects in this book, I used the laser printer. Laser copies are created with ink in the form of a dry powder called "toner." The copier heats and fuses the toner to the paper, so water media can be used on top without smearing. This eliminates the extra step of treating the paper. Laser images work most successfully for image transfers. Many commercial office supply stores have both black-and-white and color laser copy machines if you do not have access to one at home.

Vintage Photo and Clip Art Collage Characters

This exercise was inspired by the illustrator Jean-Ignace-Isidore Grandville who created whimsical drawings of animals with human characteristics, dressed in jaunty Victorian clothing. Artists belonging to the Surrealism movement invented a parlor game they called picture consequences, also known as exquisite corpse. To play, a team would cooperatively draw a figure by dividing a paper into three sections: head, torso, legs. One person would draw the head, folding the paper to hide everything but the marks on the fold. The next person would use those marks as a starting point for drawing the torso. When the third section was completed, the character would be revealed. A modern version of this game can still be seen in children's mix-and-match books.

You are seeking that intuitive spark, like finding an elusive piece to a puzzle. That wonderful aha moment, when totally unrelated images combine to reveal something completely new. I encourage you to stretch your imagination regarding human shapes. I prefer to use vintage images for my characters, but photographs from any era will work. Magazine images can also be fun to substitute for the photographs and clip art. I love doing this exercise with kids, using only a magazine for "parts."

Gather

¾" (19mm) flat brush
Black-and-white clip art
Deli paper
Fluid matte medium
Glue stick
Laser copies of photographs of people
Plastic card or scraper
Scissors

Creating a Character File

I use several methods to keep my collage characters and drawings as references for future projects. The biggest advantage to having a Character File is that when you are ready to work, you have many references that are truly your own. Here are some ideas for storing your characters:

» Use a photo storage book for loose drawings.
» Scan your best clip art collage characters and drawings into the computer.
» Keep a folder with plastic sheet protectors. Stash your drawings by size, and they will be ready to pull out and use directly in your art.
» Keep a sketchbook or draw and paint directly in an old book. Books allow you to see your progress over time.

Most important, keep it simple so you are more likely to use whatever system you choose. You will be able to find what you need easily and are less likely to accidently throw something good away.

1

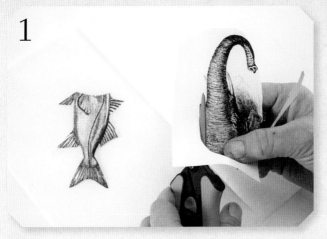

Gather the Images

Assemble a variety of clip art images to work with. Loosely trim your pieces. Do not cut the outside edges completely. Leave some excess margins to help with fitting your pieces together.

2

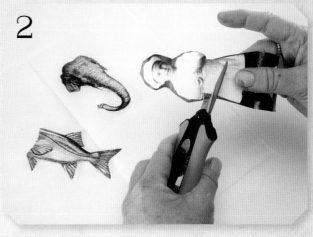

Cut the Images

Make small cuts into the images and slide them together. Doing so will give you an idea of how they will look when combined. If you have a collage piece that is too small or large for your photo, cut out the general shape on a separate piece of paper to fit your character. You can add details with pen and paint later.

3

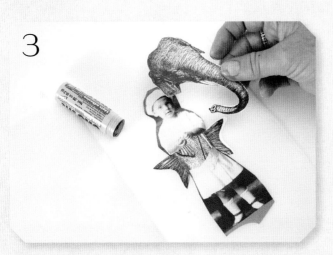

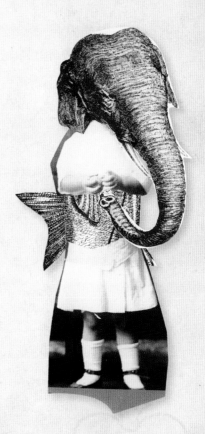

Glue the Images Together

Use a glue stick to tack your assembled pieces together. Glue your character directly onto your project with matte medium. Use your plastic card or scraper to gently remove any wrinkles.

I often make several of these characters in one sitting. I glue them on deli paper and add them to my Character File for future use.

"Creativity is that marvelous capacity to grasp mutually distinct realities and draw a spark from their juxtaposition."

Max Ernst

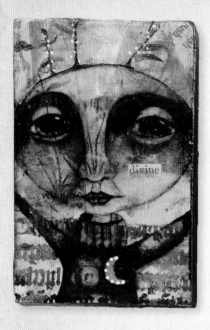

divine

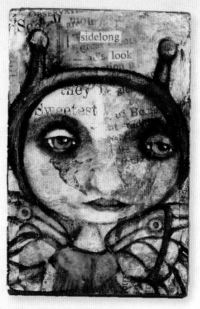

sidelong
look
Sweetest

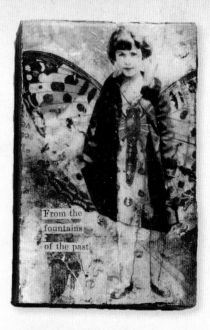

From the
fountains
of the past

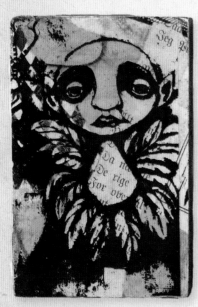

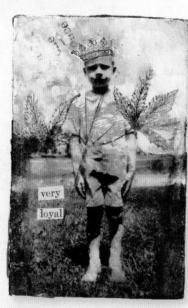

very
loyal

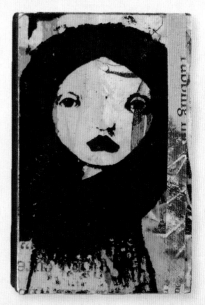

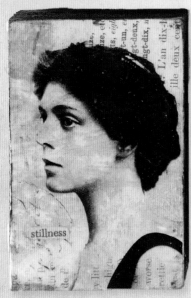

stillness

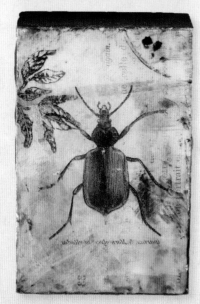

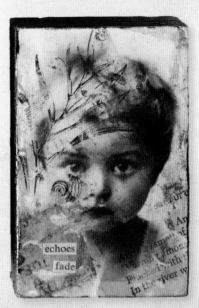

echoes
fade

Tiny Tales
Mini Art Blocks Using Tape Transfers

On a trip to Chicago, I was introduced to my first Art-O-Mat vending machine. It is a reconditioned cigarette vending machine filled with art the size of a cigarette package, 2⅛" × 3¼" (5cm × 8cm). The first piece of vending machine art I purchased was done on a wood block. It got my inspirational wheels turning.

This project is done on a wood block but works just as well on any sturdy surface that's cut to size. I use a thicker gloss gel medium as a glue for this project because it dries completely transparent and hides the tape edges. Converting your images to black-and-white will help your transfers stand out against the colorful background. Working small allows you to make many of these little pieces of art in one sitting. Once you get started, the ideas will begin to flow.

Gather

2⅛" × 3¼" × ¾" (5cm × 8cm × 19mm) wood blocks or other sturdy surface

¾" (19mm) flat brush

Acrylic craft paint: Indian Turquoise

Book page

Cardstock

Clear packing tape

Collaged deli papers

Gel medium: gloss

Gesso: white

Golden Self-Leveling Clear Gel Medium

Laser copies of photographs and clip art images

Mark-making tools: stamps, ink, pens and pencils of your choice

Plastic card or scraper

Round detail brushes

Scissors

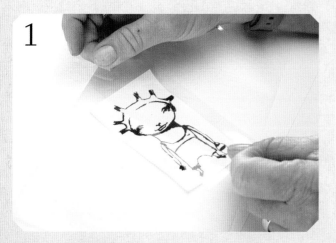

Tape the Image
Place packing tape sticky side down onto the image. Burnish the tape with a plastic card. This will ensure the paper is bonded to the tape.

Transfer the Image
Place the tape, with image attached, in warm water. Leave it in the water for a few minutes, until you see the back of the paper becoming more translucent. This indicates the water is soaking into the paper.

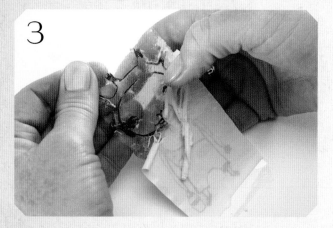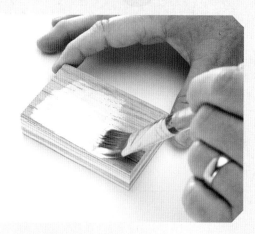

Peel Off the Paper

Remove the paper with your fingers, using a circular motion. Any white or light areas in your original image will become transparent with the transfer. Place the tape images on a sheet of deli or wax paper. The tape will still be sticky but will release easily from the waxy paper. Discard the paper pulp in the trash. It will clog your sink.

Prime the Wood

Prime the top surface of your block with white gesso. The white paint will lighten any translucent areas of the deli collage once it is glued down.

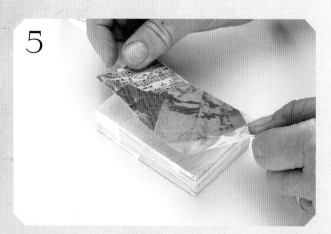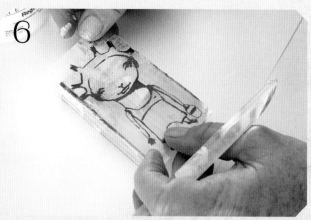

Adhere the Background

Cut or tear pieces of the deli collage a little larger than your block. Brush soft gel medium on the back of the deli collage and the surface of the block. Center the paper over the block and apply it to the surface. To eliminate wrinkles, scrape a plastic card over it or smooth it out with a soft towel. The edges can be trimmed with scissors or a craft knife once it is dry.

Adhere the Transfer Image

Cut away any excess or distracting portions of the tape transfer image. Brush soft gel medium on the back of the tape and apply the tape transfer over your collage background. Smooth out any wrinkles and excess gel with a plastic card.

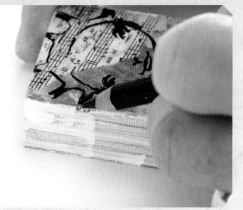

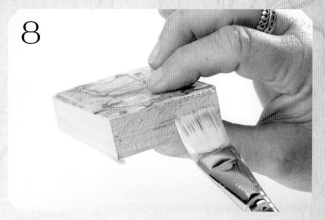

Add Details

Use your favorite mark-making tools to define your focal point or add elements to the design. I often use colored pencils to extend an existing element in the background. You can also create your tiny tale by adding some words cut from a book page or poem.

Add Color

Paint the sides and back of your block in the color of your choice.

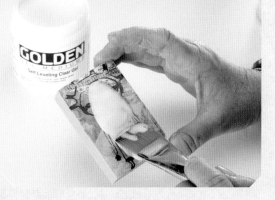

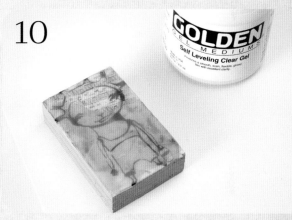

Add Self-Leveling Gel

Pour a small pool of self-leveling gel onto the surface of the block. You may need to tip the block or coax the gel with a brush to move it to the edges.

Let the Gel Dry

Set the block aside on a flat surface so the gel can level out. The gel is white when applied and becomes clear as it dries. Resist the urge to move the block or to test the surface with your finger to see if it is dry. To ensure a smooth, fingerprint-free surface, I recommend letting it dry overnight.

Visit createmixedmedia.com/ imaginary-characters to discover bonus art

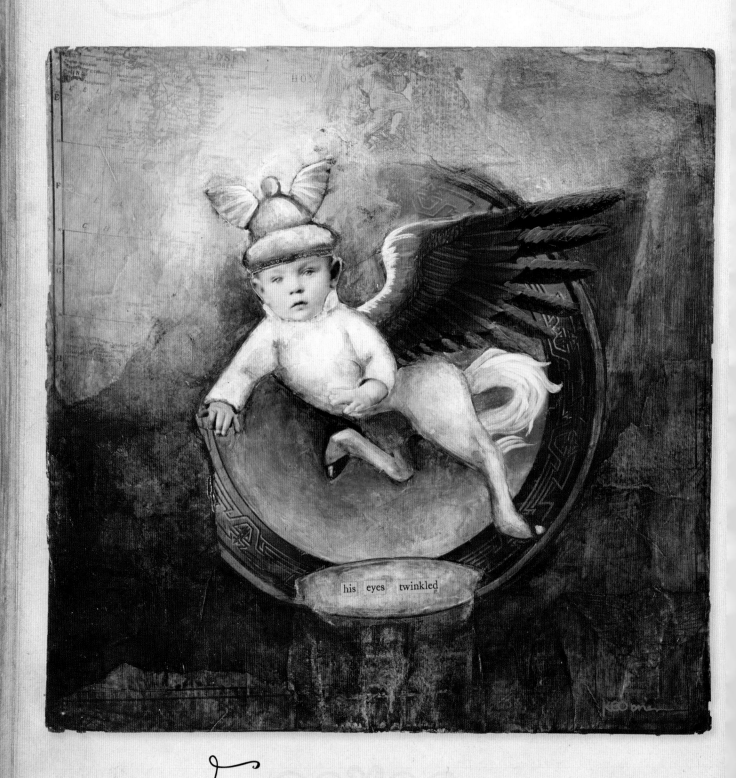

his eyes twinkled

Visit createmixedmedia.com/
imaginary-characters to discover bonus art

Heroes and Heroines
Creating a Story Using Existing Elements

Folklore and mythology often contain the story of a hero's journey. When I think of a classic illustration of a hero or heroine, I imagine a single figure so dominant that he or she almost jumps off the page. The challenge for this project is to create an iconic character and tell his or her story, using existing images on an album cover.

Begin by identifying what you want to keep and what will be obscured. Take a few minutes and really look at your cover. Now close your eyes for a few seconds and look at your cover again. Which element(s) jump out at you? Your first instinct is usually the correct one—the images that grab your interest are the ones to keep. Do the areas you are keeping include a hero or heroine? Are there elements you can use as part of a character? Are there elements you can use as a base to ground your figure? Is a theme or story beginning to reveal itself? Think out of the box when selecting items that fit your theme. Look for collage items that will create elements of surprise and unexpected contrast.

Gather

¾" (19mm) flat brush

Black-and-white clip art

Collage papers to fit your theme

Fluid matte medium

Golden Fluid Acrylics: colors that will work with your album (Transparent Yellow Iron Oxide, Transparent Red Iron Oxide, Payne's Gray, Phthalo Blue)

Heavy body acrylic paint: Titanium White

Laser copies of your main hero or heroine in several sizes

Plastic card or scraper

Record album cover

Round detail brushes

Texture stamps

Watercolor pencil: black or dark blue

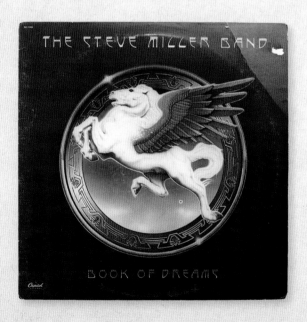

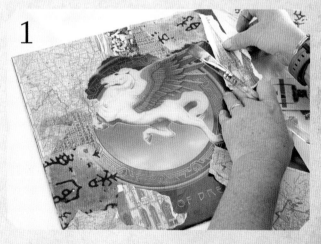

Gather Papers for Collage

Gather collage pieces to enhance the story or focal point. For this example, I selected collage elements that suggested ancient travel: maps, foreign language papers and clip art of ancient buildings. Glue the collage pieces down using matte medium. Use the collage to cover anything that does not fit your theme, such as titles and names. Work around any elements you are going to keep. Tearing your collage papers makes more interesting edges.

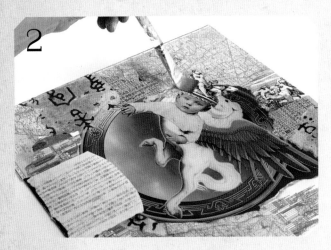

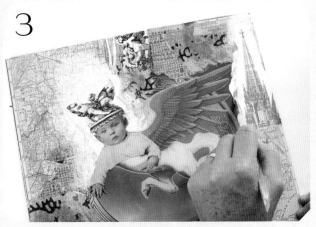

Add Collage

Arrange collage pieces to create or add to your focal point. Once you are satisfied, glue down your focal point pieces with matte medium. Add elements such as clothing, hats, arms and accessories. Try not to overthink this process; just relax and play with the different combinations until your hero or heroine is revealed. I trimmed my image to fit on the existing horse and added an architectural element for the hat.

Add White

Use a flat brush loaded with white heavy body paint to obscure elements you want to eliminate and to increase the contrast between your figure and the background. Soften the hard edges of your collaged papers with white paint and blend out with a damp cloth.

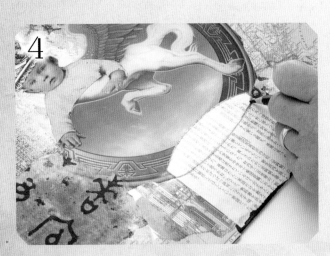

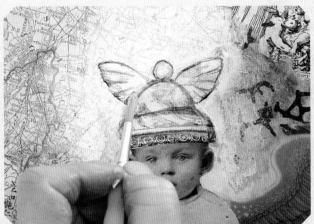

Add Detail with Watercolor Pencil

Use a watercolor pencil to draw around the edges of your character and any attached collage elements. This will help pull the focal elements together. Load a round detail brush with matte medium and blend in your pencil lines from the edges toward the center to establish some shading.

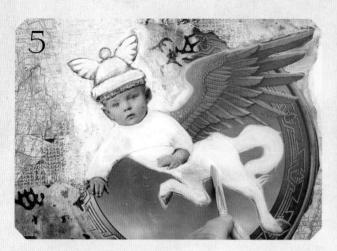

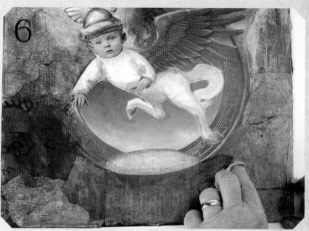

Blend the Figure's Features

Use a brush loaded with white heavy body paint to blend the transitional parts of your character with the album elements. I painted my character's shirt white and blended it into the horse's body, making it look like one piece. White highlights will bring the character forward from the background.

Paint the Background

Select fluid acrylic colors that will blend in with any original background that is showing. Apply the paint in thin layers, letting each layer dry. Use thin layers of fluid acrylic to paint over existing elements and add shadows. This will unify the colors and thereby integrate the piece.

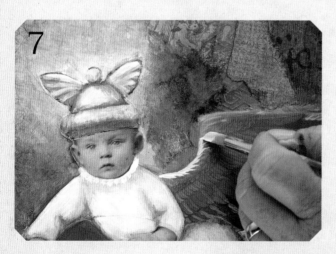

Final Details

Use your smaller brushes to add final details. I mixed Payne's Gray and Transparent Red Iron Oxide to make dark brown. I used this color to glaze the bottom areas of the album, then wiped off most of it with a damp rag. The darker color provides an antique look and grounds the figure.

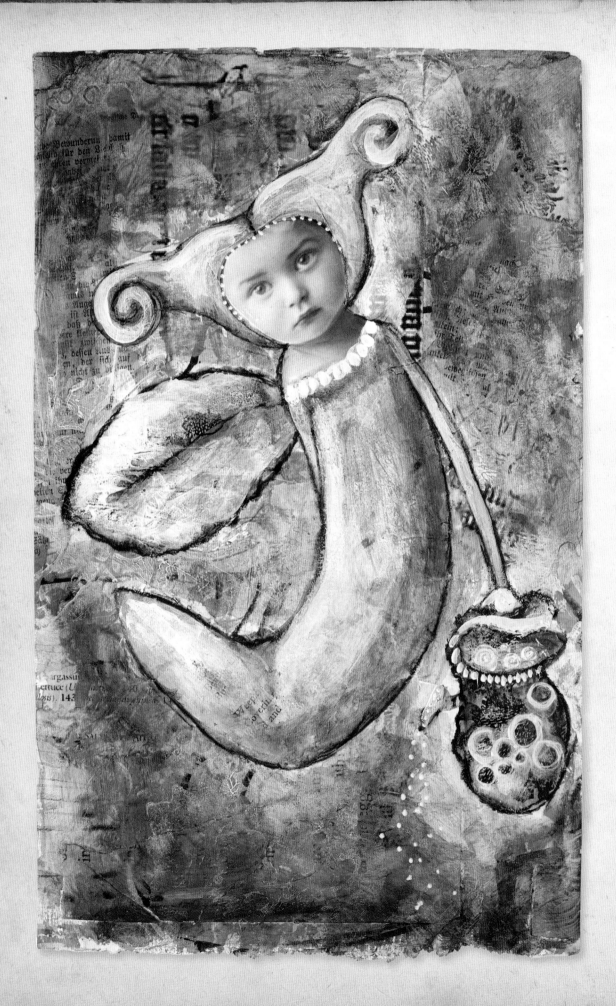

Myth and Mystery
Integrating Figures Into a Collage Background

Mystery can be defined as something secret or unexplainable—something with an obscure or puzzling nature. In this project you will create a mysterious creature of myth by using many of the techniques we have covered in this chapter.

Any surface that will hold up to paint and collage can be used for this project, but I suggest using one of my favorite papers, red rosin paper. Red rosin paper can be found at home improvement stores in the paint section. It is inexpensive, can be cut to the size of your project and stands up well to mixed-media techniques.

I chose to use the head and neck from a vintage photograph to begin my figure. Look for shapes and background collage elements to combine with your figure and help tell a story. You can always add more collage if you need more to work with. During the process of adding color to the background, a baby wipe can be used to rub through a stencil in random areas. Doing so will lift off some of the color and leave a subtle pattern, thereby adding even more mystery.

Gather

¾" (19mm) flat brush
Baby wipes
Book page
Black-and-white clip art
Fluid matte medium
Foam or texture stamp
Gesso: white
Golden Fluid Acrylic paint in your choice of colors
Heavy body acrylic paint: Titanium White
Laser copy of a photograph or a character you created from your Character File
Mark-making tools
Plastic card or scraper
Red rosin paper
Round detail brushes
Scissors
Stencil: abstract or texture pattern
Watercolor pencil: black or dark blue

Prime the Background

If you are using the blotter collage from the Deli Blotter Collage exercise, skip to step 3.

To create a new background, drizzle a small amount of gesso on the red rosin paper and spread the gesso with your plastic card.

2

Collage and Paint

Follow the Deli Blotter Collage project steps 1–9 to paint and collage a background. Use a flat brush with white heavy body paint to obscure areas you want to minimize and unify smaller pieces of collage. If your background needs more light, stamp with a foam or texture stamp loaded with white paint or gesso.

3

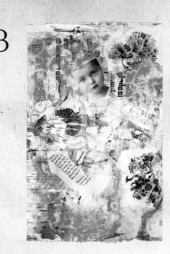

Add the Character

Place your character on the background, looking for shapes and elements you can use for parts of the body. You can add unexpected collage elements like pottery, buildings or plants to make unique bodies and use a wash of thinned white paint to veil their origins.

4

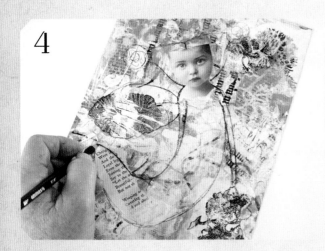

Define the Character

Use a watercolor pencil to define your character's shape or to add new elements to your design.

5

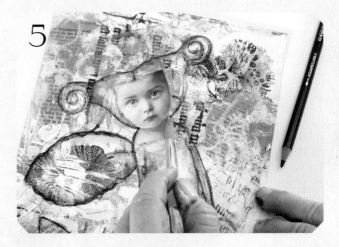

Build Up the Figure

Wet a detail-size brush with matte medium and paint along the watercolor pencil line. Start moving the watercolor pencil into the center of your lines, blending and blotting to soften the lines.

Layering

Work the whole painting, not just one section. Continue to alternate between adding highlights and color until your character jumps off the paper. Adding multiple layers increases the richness and complexity of the colors. Have patience with the process; the early layers are the hardest to get excited about.

Visit createmixedmedia.com/ imaginary-characters to discover bonus art

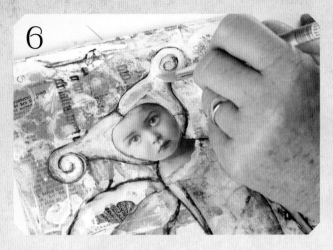

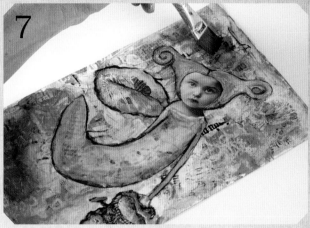

Add White

Use white heavy body paint to blend the transitional parts of your character and to eliminate distracting elements. Add more white paint along the figure edges to highlight your figure and bring it forward. Blend and soften with a damp rag.

Add Color

Add color to your character using a small brush loaded with fluid acrylic paint. Thin the paint with medium if the color is too intense. Using a wide brush, apply full-strength fluid acrylic paint randomly to the background. Blot the edges to soften them. Let this layer dry. Apply additional layers of colors to deepen the effect.

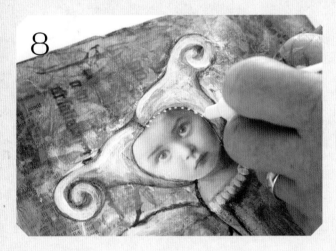

Final Details

Use pencils, markers or other drawing tools to add details to the piece. My favorite is a white water-soluble paint pen. Add some text from a book to create even more mystery. Stain the text with thinned fluid acrylic to blend it in.

Mounting Finished Pieces

Once your piece is completed, it can be matted and framed, but my preferred method of mounting finished pieces is to attach them to wood using gel medium. Spray the wood surface lightly with water to help with the spread of the gel medium. Coat the wood and the back of the paper generously with gel medium. Lay the paper on the wood surface. Use a plastic scraper to press from the center out to the edges of the entire piece. Use a rag to clean up the excess gel that accumulates on the edges. Place a piece of wax paper or deli paper over the top to prevent sticking, and place your piece facedown on a flat surface. Put a heavy object, like a book, on it to weigh it down. Let it dry overnight. The edges can be trimmed and painted for a finished look.

DRAWN FROM YOUR IMAGINATION

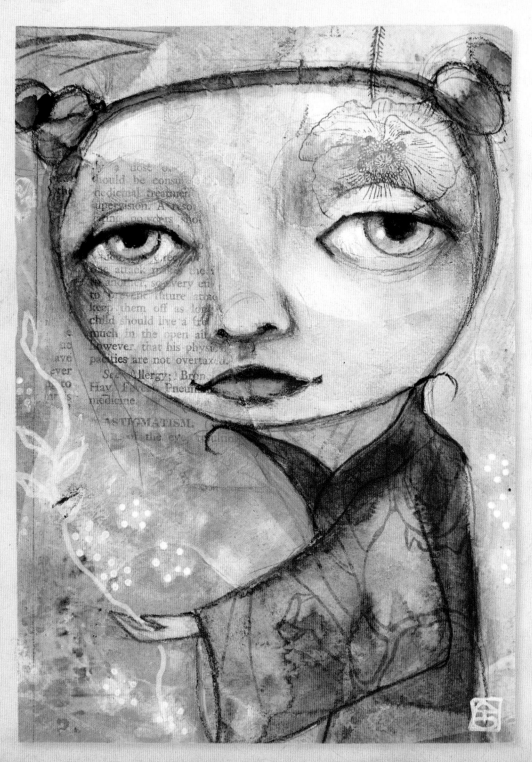

Approaches to Discover Your Unique Drawing Style

Every old master began with an apprenticeship. They learned from others and constantly practiced their techniques to perfect their craft. The more you practice and play, the better you will get. Look at your work grouped together. You will be amazed to discover that you are developing muscle memory for a face that is unique to you. Certain attributes will appear over and over again in your drawings.

An apprenticeship is an opportunity to get to know your magical tools. Simple pencils can be enhanced with mediums to increase their intensity and alter their look. I have three favorite mediums: matte medium, absorbent ground and clear gesso. I use matte medium in place of water to render the shading and marks permanent. Clear gesso dries to a clear rough surface, which intensifies the color of your pencils. I use it sparingly on specific areas that are resisting my pencil work. Absorbent ground

is a translucent medium that will provide a muted, unified layer over collage and changes a nonabsorbent surface into one that will accept watercolor. These mediums will give you options when you're working directly on a surface that is producing less than the desired effect.

I have found that simple is better when it comes to drawing. If you learn the structure and locations of the facial features in a classic face, you can alter them to produce an infinite village of exceptional urban folk. Play with the shape of the face: oval, round, elongated, triangular or uneven. Draw the eyes high, low, wide, close, cockeyed, open, closed, squinty, small or large. Make the nose short, long, fat, thin or crooked. The mouth may be open, closed, smiling or pouting. The lips can be puffy or thin. The secret that makes faces come alive is adding dimension with realistic shading.

Our Tale

The next night, the girl dreamed of meeting the Master of Drawing. He looked an awful lot like her favorite teddy bear, except for the spiral tattoo on his palm. He told her the spiral symbolized growth, confidence and magical support. The Master welcomed her to sit and encouraged her to tell him about her journey. She shared her wish to become better at drawing people. The Master agreed to become her teacher and showed her many new ways to improve her drawings. Over time, she realized the most important lesson was to practice, practice, practice.

Chapter Treasure

Grow.
Practice and expand skills.
Make the most of your magical tools.
Discover the path to
your unique style.

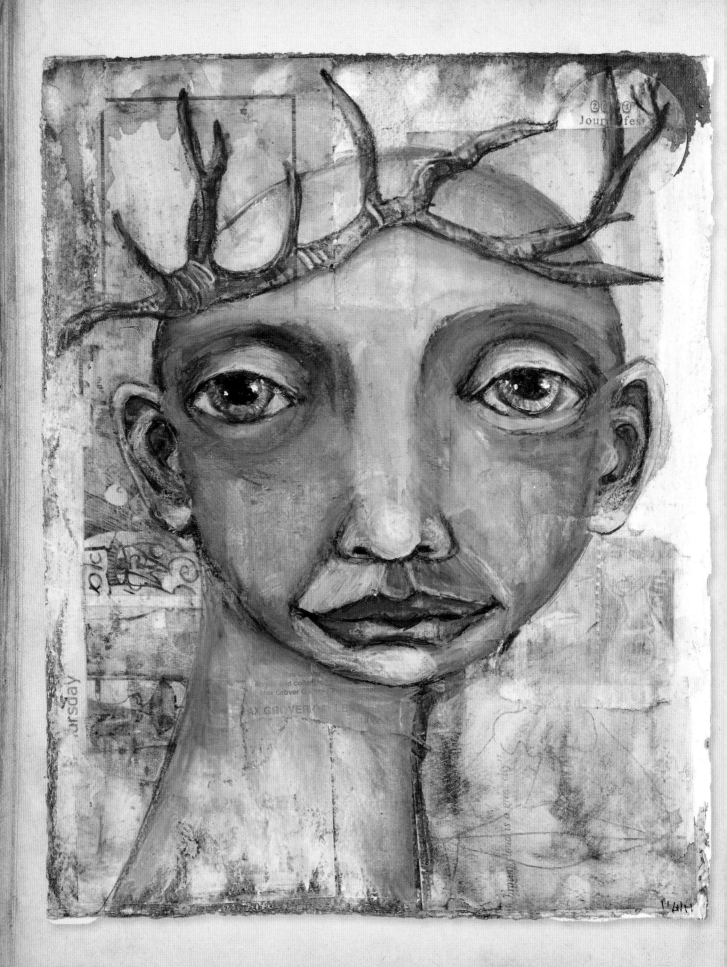

Secrets to Creating Unusual Faces
Proportion Basics

Going back to Leonardo da Vinci, science and math have been used in an attempt to define perfect beauty. Symmetry of the face has been linked to attractiveness for ages. Ironically, human faces are not perfect and certainly not symmetrical. This is what makes them so interesting! We are trying to achieve unique and edgy faces, but it helps to know the proportions of a classic face before you alter them. A visual and functional way to help you understand the classic proportions can be found using a grid system. The grid provides a structure to locate the positions of the features of the face. I use a simple, informal grid to make a classic face. I don't measure with a ruler, but I do make faint lines to help me get the proportions correct. Before you begin, become familiar with the general rules for standard proportions:

>> The eyes are halfway between the top of the head and the chin.

>> The bottom of the nose is halfway between the eyes and the chin.

>> The mouth is just above the halfway line between the nose and the chin.

>> The top of the ears line up with the center of the eyes.

>> The bottom of the ears line up with the bottom of the nose.

Gather

Blending stump

Graphite or mechanical pencil with eraser

Packet of unlined index cards 4" × 6" (10cm × 15cm) or sketchbook

"Learn the rules like a pro, so you can break them like an artist."

Pablo Picasso

1

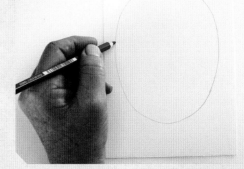

Sketch the Face Shape

Loosen up by doing a series of ovals in an easy, continuous movement. Pick the oval line you wish to use and darken it with your pencil. The top of the oval is the crown of the head. The bottom of the oval is the tip of the chin.

2

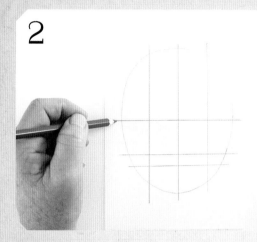

Draw the Guidelines

Using light pencil lines, draw a horizontal line midway between the crown and the chin to divide the oval in half. This is the eye line. Draw a horizontal line midway between the eye line and the chin. This is the nose line. Draw a horizontal line midway between the nose line and the chin. The mouth line is at, or slightly above, this line. Draw a center vertical line dividing the face in half. This is the center line of the face. Draw a line on the right and left sides of the center line, midway between the center and side of the face. The cross over the eye line is the center of the eye.

3

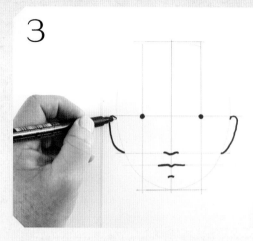

Mark the Features

Take your pencil and make dots for the eyes and nose, and a line for the mouth. Use the horizontal lines to locate the ears. These are the classic locations for the facial features.

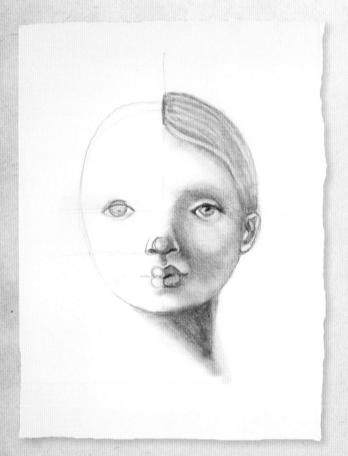

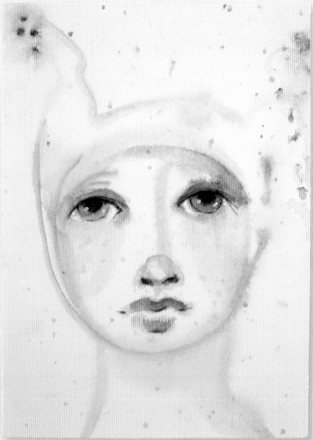

Playing With Proportion

Now that you have a sense of classic proportion, it's time to break the rules. You are on a quest, searching for the beauty of imperfection and your own unique style. Drawing faces by playing with proportion and location will help you get there. Consider your favorite cartoon characters or the artists who use exaggeration in their work. Collect images that have faces that speak to you, and see if you can find a pattern. Are you attracted to similar characteristics? Take a face and alter it. Some words of wisdom from Dr. Seuss: "Think left and think right and think low and think high. Oh, the things you can think up if you only try!"

Gather
Unlined index cards or sketchbook
Graphite or mechanical pencil
Permanent marker

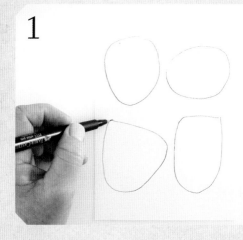

1

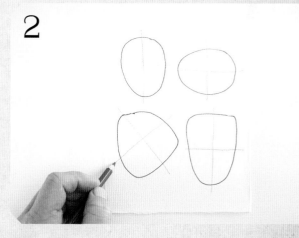

2

Draw Face Shapes
Draw four to six different face shapes on paper: oval, round, elongated oval and an uneven round shape, such as a pear.

Draw the Guidelines
With a pencil, sketch vertical and horizontal lines to create a grid, using the steps described in Proportion Basics. These lines will give you a general idea where the eyes, nose and mouth are traditionally located.

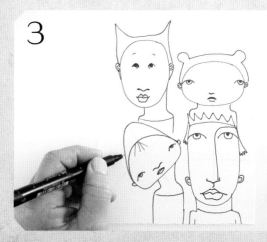

3

Refine the Characters
Play with manipulating the shape, size and distance of the eyes, nose and mouth on each face shape. You might try keeping the nose and mouth on the correct lines but move the eyes up or down, or make them narrow or wide. Exaggerate the features; try making them oversized, petite or a combination of both. Add any loose drawings to your Character File.

Shading

The human face is made up of many different elements: eyes, cheeks, lips, a chin and so on. None of these elements are flat; they are all dimensional. By breaking the human facial features down into separate elements, you will notice that many of them are shaped like a ball. Learning how to shade a ball (or round object) will help you shade the face.

Decide where the light source will come from for your drawing, and place a light arrow in the corner as a reminder. Light will create a bright spot, with a gradient to darker shadows on the opposite side. Shading is what makes the difference between a believable unique face and one that is more cartoonlike.

Gather

Black-and-white reference photograph of a face

Blending stump

Direct light source: desk lamp or similar

Graphite or mechanical pencil with eraser

Stick eraser

Round object: a ball or orange

Unlined index cards, 4" × 6" (10cm × 15cm), or sketchbook

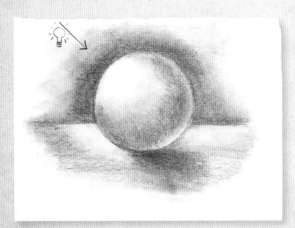

Light and Shading

Set up a round object, such as an orange or a rubber ball, with direct light. Draw or trace a circle on your paper. Start with the darkest area, farthest from the light source, shading with your pencil.

As you move toward the light source, fill the circle with less and less pressure. Go heavier on the dark area, lighter on the light area. Leave a round spot the color of the white page closest to the light source. Use your finger or a blending stump to blend the shading and add a shadow. Notice how the circle now appears to have dimension. Use an eraser to accentuate the highlighted areas.

The Mouth

Draw the mouth by starting with the centerline, where the lips meet. Draw two circles centered on the top and below the line. Draw a line from the end of the dividing line that contours over the circles to create the upper and lower lip. Draw the mouth with the centerline broken and darker than the outline. Shade the mouth.

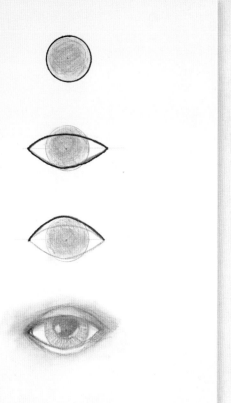

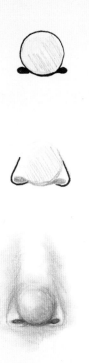

Eyes

Draw eyes by starting with a circle. This will be the iris of the eye. Draw an arched line across the circle, dissecting it about a third of the way down from the top to create the upper eyelid. Draw an arched line across the bottom of the circle to create the lower lid. Draw an arched line across the top of the circle to create the eyelid crease. Once you have the structure, add the pupil as a partial circle inside the iris. I usually tuck it in just under the upper eyelid. Shade the eye.

The Nose

Draw the nose by starting with a circle. Draw two small ovals at each side of the base of the circle and connect them with a line. This creates the openings of the nose and the nose tip. Draw a curved line on the outside of the ovals to create the nostrils. Shade the nose.

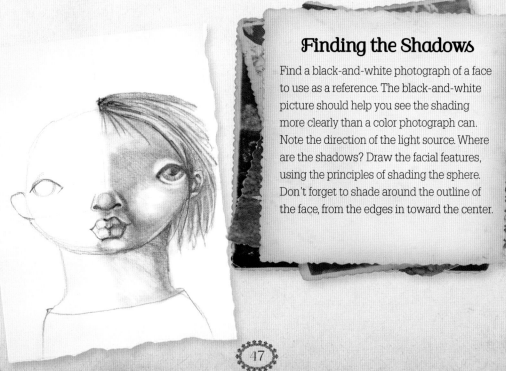

Finding the Shadows

Find a black-and-white photograph of a face to use as a reference. The black-and-white picture should help you see the shading more clearly than a color photograph can. Note the direction of the light source. Where are the shadows? Draw the facial features, using the principles of shading the sphere. Don't forget to shade around the outline of the face, from the edges in toward the center.

100 Faces

The best way to develop your drawing skills is to draw many, many faces. My favorite way to keep track of how many faces I draw is to use blank index cards, which come in sets of one hundred. I leave piles of them scattered throughout the house. This ensures that when I get the urge to draw, there is always some paper to work on. It is quite rewarding to reunite the stack of cards and see so many different faces.

A trick to developing loose and easy original faces is to remove some control over your mark making. This can be done by changing your approach or tools to make it harder to do the same face over and over again. Varying your drawing tools, changing your grip, using your nondominant hand and taping a stick onto a pencil or pen are all ways of changing your drawing outcomes. Draw from your imagination and from reference photographs that inspire you. I love drawing from art doll and sculpture magazines, but any face will do. There is something to be learned with every drawing you make. Set a personal goal to do a drawing on every card in your pack, promising not to throw any away! Add them to your Character File for future reference.

Gather

100 Unlined index cards 4" × 6" (10cm × 15cm)
Permanent marking pen: black
Reference photographs

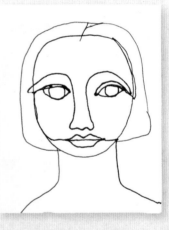

Draw a face without lifting your pencil/pen off the page.

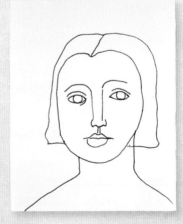

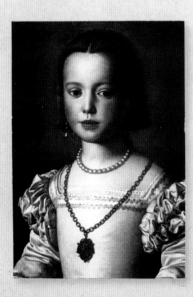

Reference used for this exercise: Bia de' Medici, by Agnolo Bronzino

Draw a face using only the contour lines or edges of the face and features.

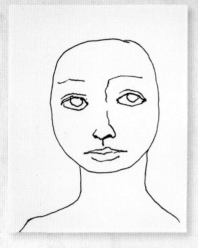

Draw a face with your nondominant hand.

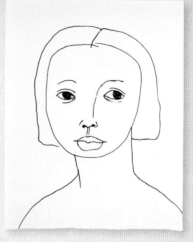

Draw a face using a reference photo. Look at the reference 60 percent of the time and your paper 40 percent.

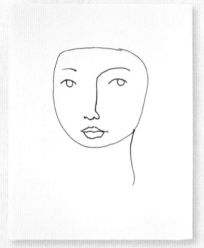

Draw a face using only ten lines.

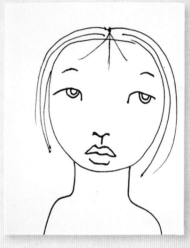

Look at the drawings and select one to repeat in a stylized manner by changing one or more of the facial features.

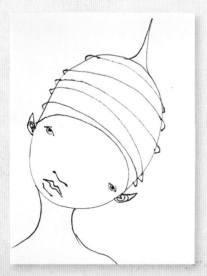

Use your stylized drawings as inspiration.

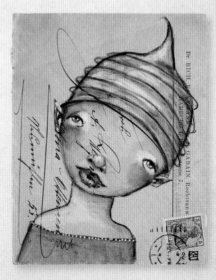

Take it further by using the original drawing as a reference and refine it with watercolor pencils and gouache on an old envelope.

GAGFAH
Gemeinnützige Aktien-Gesellschaft
für Angestellten-Heimstätten
Bezirksgeschäftsstelle ...ourg
② HAMBURG 36
Karl Muckplatz 1 (Zimmer 941)
Hamburg ...berg 68
...bh, Borgweg

HAMBURG
21.7.45.-11

Gouache With Watercolor Pencils

One of my favorite projects entails creating faces on old book pages, combining watercolor pencils and gouache paint. You can minimize the wrinkling of the paper by working fairly dry, but a little wrinkling is part of the charm. Watercolor pencils have a binder that is water soluble. This means that the pencil marks can be activated with water, even after they have dried. The advantage of this is that marks can be removed or corrected with water or a baby wipe. The pencils behave like paint when water is added. The color can be blended, feathered and spread with a brush. A watercolor pencil will allow you to have more control when applying color in smaller areas. Gouache is an opaque watercolor that remains "live," like the watercolor pencils, even after it dries. Gouache blended with watercolor pencils results in a dreamy, soft matte finish that cannot be achieved with acrylic paint. Using matte medium for blending, instead of water, prevents the pencil and gouache from reactivating.

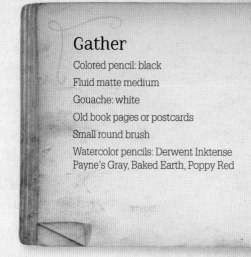

Gather

Colored pencil: black
Fluid matte medium
Gouache: white
Old book pages or postcards
Small round brush
Watercolor pencils: Derwent Inktense Payne's Gray, Baked Earth, Poppy Red

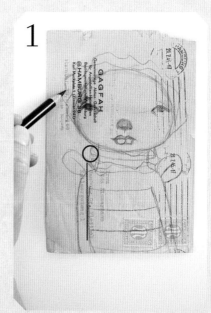

1

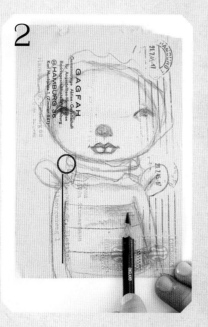

2

Draw the Figure

Draw a character onto an old envelope using a dark watercolor pencil. I used a Payne's Gray pencil for this.

Add Shading

Make adjustments to the drawing with the watercolor pencil and add shading to the features. I used a black colored pencil to darken the pupils of the eyes, upper eyelid, nostrils and the shadow between the upper and lower lips.

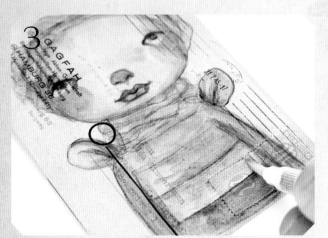

Add Color

Using a brush wet with matte medium, blend the pencil in the areas where you added shading. Add color and once again use the brush and matte medium to blend the pencil. Clean your brush often during this process so your colors don't mix.

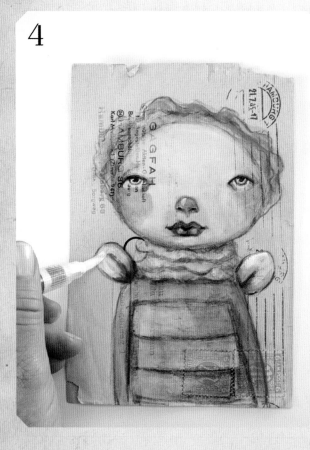

Add Gouache

Load a clean brush with white gouache and add to the areas you want to highlight—in this case, the face and the wings. Work back and forth between adding shading with the pencil and highlights with the gouache until you are satisfied.

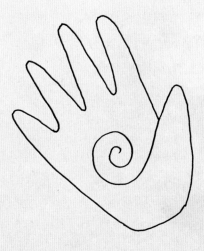

Visit createmixedmedia.com/ imaginary-characters to discover bonus art

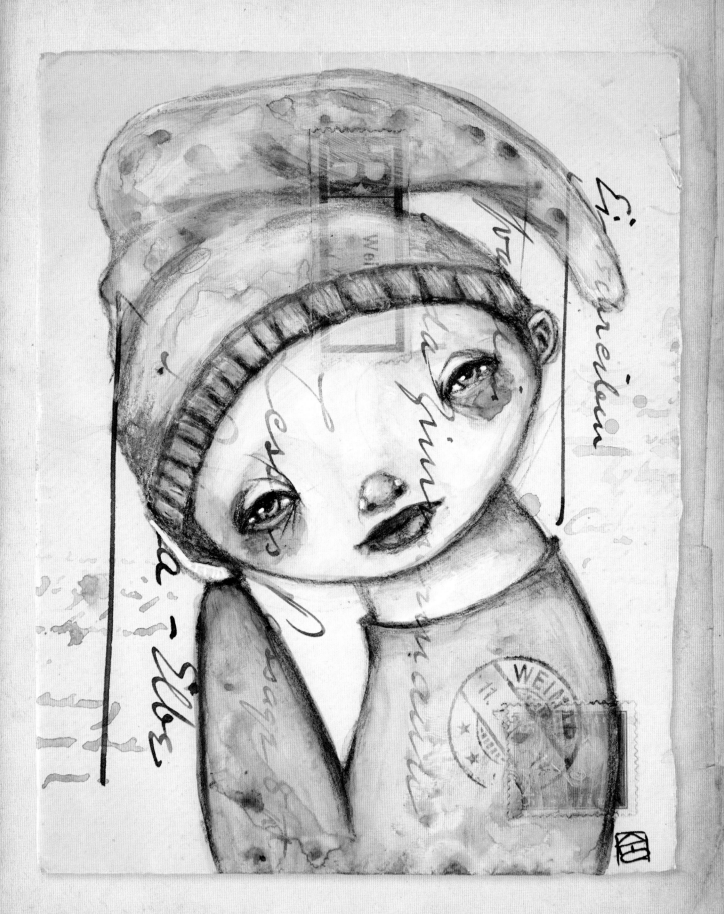

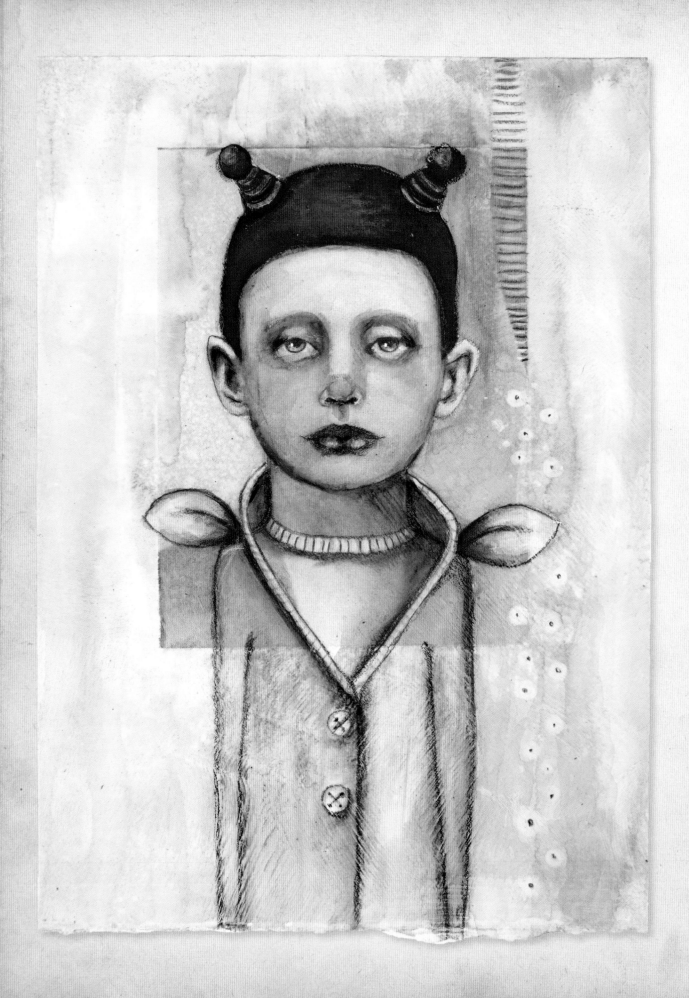

Combining Pencils and Mediums Over Photocopies

Hand coloring black-and-white photographs was a popular technique used before the invention of color film. It was a way to add an artistic touch and increase the realism of black-and-white photographs. Color was applied to the original photograph with various mediums and tools. The effects were subtle and a bit mysterious. Working over a black-and-white or sepia photocopy is a fun way to get a similar look. If you are still struggling a bit with drawing a face, painting over an image lets you practice drawing and painting a face with the basic location of the facial features already in place. This exercise combines many of the skills and techniques covered earlier in this chapter and gives you a chance to work with absorbent ground and pencils. The absorbent ground will definitely increase the intensity of your marks, so I recommend a light hand to begin with. More pencil can be added as you proceed. Try altering the existing face and add fun features like clothing and hats. Elements in the background of the photocopy are opportunities to creatively integrate them into the composition.

Gather

¾" (19mm) flat brush

5" × 7" (13cm × 18cm) Bristol paper or hot-pressed watercolor paper

6B graphite pencil

Blending stump

Colored pencils: Prismacolor White, Cream, Crimson Red, Dark Brown, Black

Fluid matte medium

Golden Acrylic Absorbent Ground

Gouache: white

Kneaded eraser

Laser photocopy image 3" × 5" (8cm × 13cm)

Pan watercolor set

Plastic card or scraper

Small round brush

Watercolor pencils: Derwent Inktense Poppy Red, Baked Earth, Bark

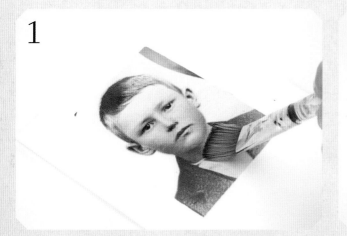

1

Adhere the Image
Glue your image to your chosen surface with matte medium and smooth out the wrinkles with a plastic card or scraper. Let dry before adding the next layer (to prevent further wrinkles).

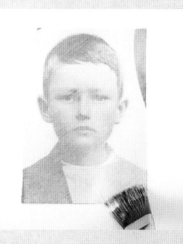

2

Add Absorbent Ground
Paint the entire surface with absorbent ground. Painterly brushstrokes will give the final piece added texture. Let this dry thoroughly.

3

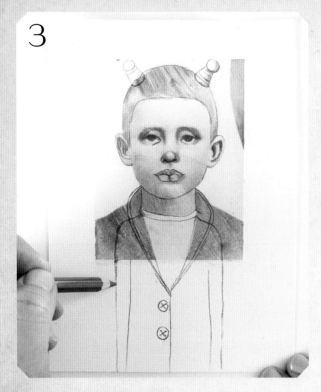

Draw the Character's Features

Using your 6B graphite pencil, add a simple body shape and sketch details for the figure (collars, buttons, hat, ears, etc.) and some initial shading. Use a light hand with the pencil applications as the absorbent ground picks up quite a bit of pigment. Use the blending stump to blend the shading.

4

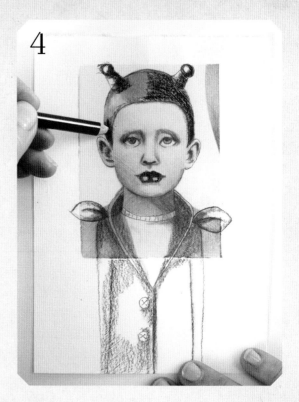

Add Color

Use colored pencils to color the figure and clothing, and add shading. A colored pencil layer will give you more color depth.

5

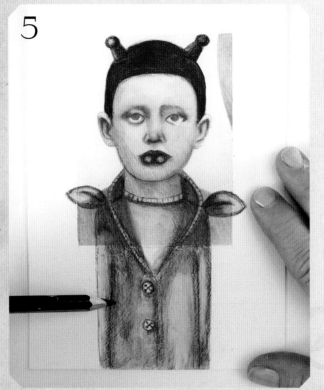

Blend the Colors

Use watercolor pencil over the colored pencil to shade the clothing. Blend the pencil using a brush loaded with matte medium. Work fairly dry, and clean your brush often. This will prevent the drawing from getting muddy. Work back and forth between pencils until you are satisfied with the color.

6

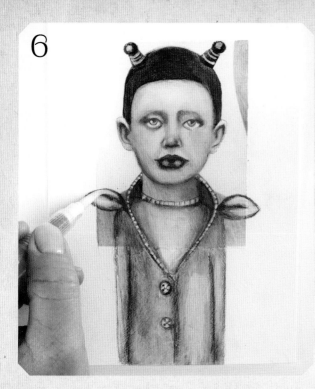

7

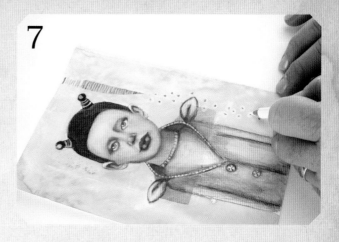

Final Details
Apply a watercolor wash over the background. At this point you can use pencils, markers and paint pens to add final details and visual interest.

Add Gouache
Use white gouache to add highlights and blend the pencils together.

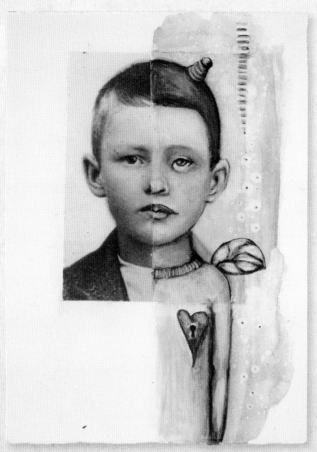

Sometimes drawing on only half of the photo can make for an interesting variation. Don't feel like you have to cover everything up!

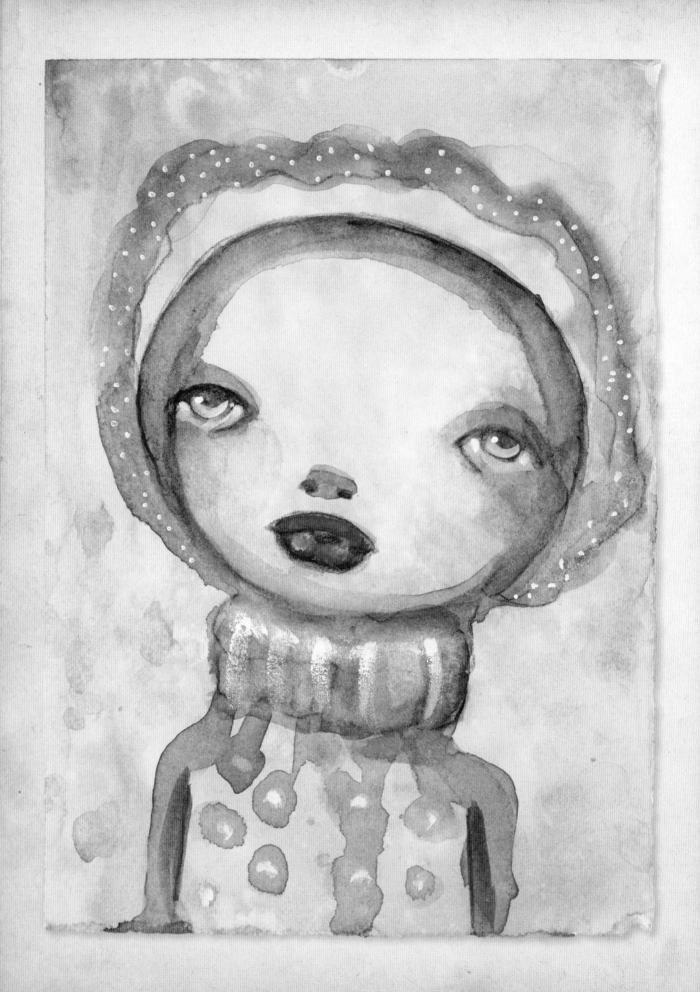

Dreamlike Watercolor Faces

Long ago and far away, there was a land of happy accidents. A place where paint had a mind of its own, and fresh, original characters revealed themselves. This exercise is about creating dreamlike characters by letting the mediums and tools do the work for you. Get some distance from the painting surface by standing and using a larger brush with a long handle. Mixing lots of water with your paint will also prevent you from worrying about details. Relax your control and enjoy the process. It is easy to fall in love with the dreamy way watercolor travels and pools on a wet surface. Line up three to five blank surfaces to work on, and flow from one painting to the next. By the time you get to the last painting, the first one should be almost dry and you can begin to add some detail with pencil and gouache. Letting the paintings air dry is important to the dreamy look. A hair dryer will push the paint around, distorting your images. Setting a timer so you do not spend more than 10 minutes on each piece will prevent you from overworking and creating mud.

Gather
Colored pencils
Gouache: white
Largest round brushes you own: No. 10 or 12
Pan watercolor set
Spray bottle
Watercolor paper
Watercolor pencils

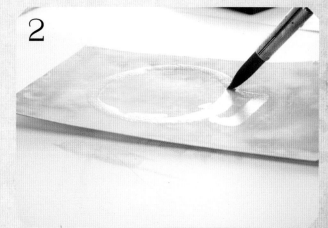

1
Paint the Background
Do a light watercolor wash on the watercolor paper with two colors. Let it dry.

2
Draw the Face
Grip your brush loosely, dip into clear water and draw the face shape.

3

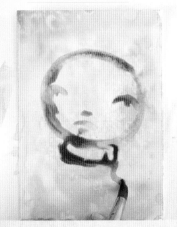

Add Color

Add watercolor paint to your brush. Drop the tip with paint into the wet line and let the color spread. Tease it around the shape with your brush.

4

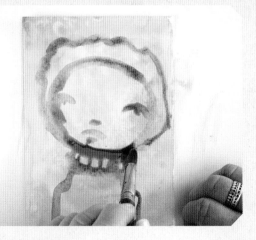

Build Up the Figure

Repeat the process of drawing with water and dipping in the color for the features of the face.

Tilt the paper a bit to get some fun drips. Don't worry if your paint is bleeding into areas you do not want it to go. This is part of creating a loose, interesting face. Let the watercolor dry.

5

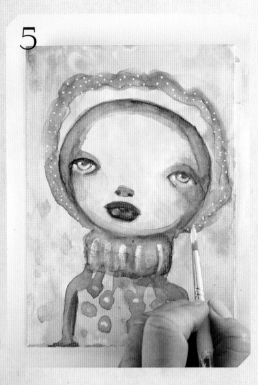

Final Details

Use watercolor and colored pencils to refine the features. Add highlights with white gouache. Work back and forth between pencils and gouache, as you've done in previous exercises, until you like the results.

Adding More Details

You have the option to add more watercolor to the background. I usually choose to do this if there is not enough contrast between my figure and the background. I will often flick watercolor off my brush to add texture. If there's an area you do not like, you can collage over it and paint with absorbent ground. When the absorbent ground dries, you can add the lines and watercolor back in.

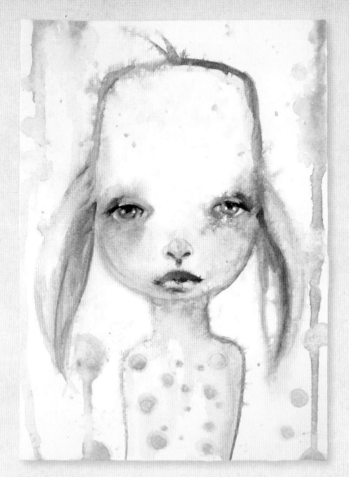

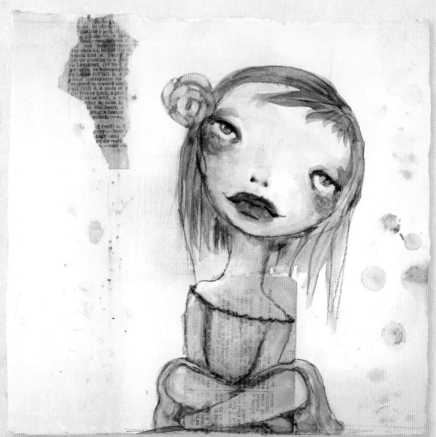

Fairy Chain
Paper Doll Chain Using Practice Drawings

Raphael Tuck, a London company that patented its first paper doll in 1893, was one of the first to produce a set of paper dolls with many outfits to choose from and interchangeable heads. The company was well-known for its series of fairy-tale paper dolls, which included Prince Charming. You may have childhood memories of cutting out paper dolls and being lost for hours making up stories. The connection of paper dolls to play, childhood and fairy tales inspired this project. I chose a paper doll chain because it is a great way to create a display for some of your creative faces, and it will sit on a shelf nicely. Use your growing Character File as a source for your faces. I selected four faces that are about the same size for the project, each drawn with a different medium. The dimensions of this project can be modified to create a longer chain or even full-body paper dolls. How fun would that be!

Gather

¾" (19mm) flat brush

Collage and clip art for accents

Faces from any of the exercises in this chapter (sample faces are 2½"– 4" [6cm – 10cm])

Fluid matte medium

Graphite or mechanical pencil with eraser

Mark-making tools: your choice

Pan watercolor set

Ruler

Scissors

Watercolor paper cut in a strip sized to your project (sample project is 6" × 22" [15cm × 56cm])

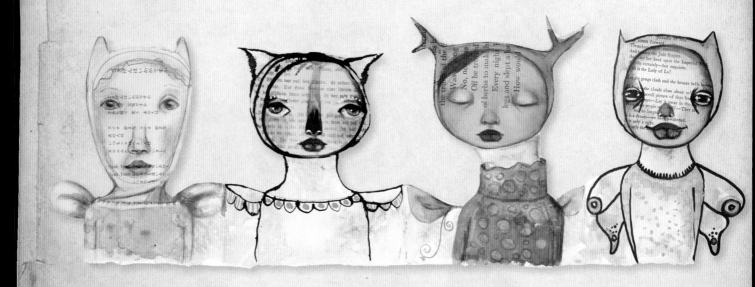

Visit createmixedmedia.com/ imaginary-characters to discover bonus art

1

Paint the Background

Fold the paper into four equal sections and do a watercolor wash on both sides of the paper. Set it aside to dry.

2

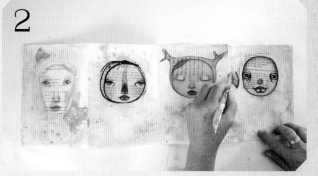

Adhere the Faces

Glue your faces in each section using matte medium. The placement will depend on how much body you will use for your dolls. If you are making just a head with a neck and shoulders, make sure you leave enough room at the shoulders to connect each doll.

3

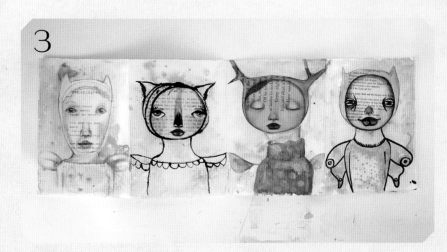

Refine the Figures

Use pencils, pens, paint and ink to define your dolls. I chose to finish each doll with the same drawing tools I used to make each face to tie them together.

4

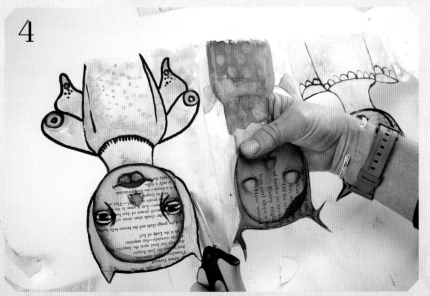

Cut Away the Excess

Cut out the silhouettes, leaving a connection between each doll at the bottom.

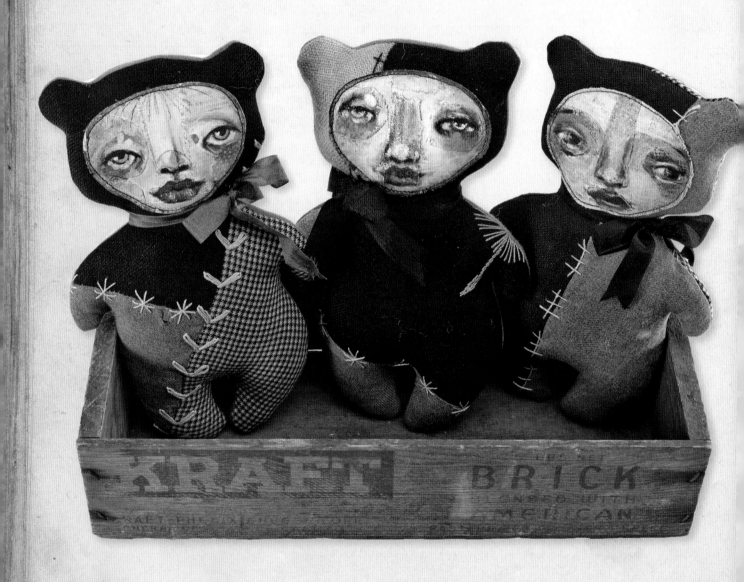

Visit createmixedmedia.com/
imaginary-characters to discover bonus art

Animal Guide
Paper and Fabric Collage Art Doll

Many years before I discovered collage and paint, I was a teddy bear artist. I began that chapter of my art journey with a pattern for a teddy bear with a rag doll body. I shared what I made with friends and began receiving requests to make more. Soon I was traveling all over the country doing shows and selling my bears. I made many bears and grew tired of naming them. I started making little collage tags and cutting out random words to put on the tags. The word on the tag became the bear's name. I loved the process, and soon my collage pieces grew in size and I started to add painting. I share this story to show that you never know where an interest will take you. The art you make now and the things you learn are invaluable to your growth as an artist.

The bear is my animal guide. It brought me to the place I am now, writing this book. I felt strongly that I should honor my roots and include a simple bear project. I stumbled on the idea of using fabric as collage by accident. With some trial and error, I created a unique face combining paper, fabric and pencils. I have included a simple bear shape to sew your face on, but your faces could also be used on a doll or journal page.

Gather

¾" (19mm) flat brush

4" × 5" (10cm × 13cm) muslin scrap

Animal guide pattern printed on 8" × 11" (20cm × 28cm) cardstock (page 124)

Book pages

Chopstick or stuffing tool

Clear gesso or absorbent ground

Colored pencils

Deli sheet or wax paper

Fluid matte medium

Graphite or mechanical pencil

Heavy body acrylic paint: Titanium White, Titan Buff

Needle and thread

Pinking shears

Plastic card or scraper

Polyester fiberfill

Ribbon

Scissors

Selection of patterned cotton fabrics, small pieces

Sewing machine

Small round brush

Straight pins

Two 8" × 10" (20cm × 25cm) pieces of muslin, cotton, wool or vintage quilt fabric

Watercolor pencils

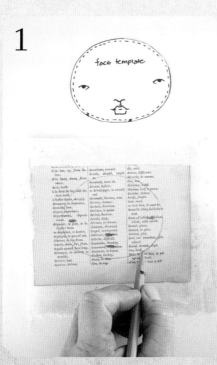

1

Sketch the Face

Place a deli sheet or wax paper underneath a piece of muslin. Glue vintage book paper to the muslin with matte medium. Let it dry. Cut the face template from the pattern and use it to draw the face shape. Make marks in the general area where you want the eyes, nose and mouth to be.

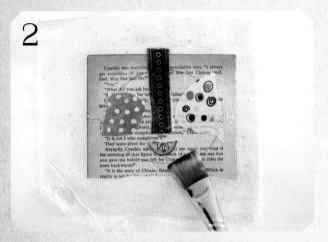

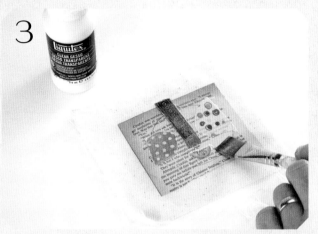

Collage the Facial Features

Select small pieces of fabric to use for your face. Darker fabrics act like shading. Look for shapes in the patterns that might suggest eyes, a nose and mouth. Try different combinations until you're happy with one. These patterns can be subtle or more recognizable; it's up to you. Cut the pieces to fit over your markings, and glue them in place using matte medium.

Seal the Collage

Apply a thin coat of clear gesso or absorbent ground over the face. Either medium will allow you to work with pencils over the top of the fabric. The clear gesso will make the fabric patterns more prominent; the absorbent ground will mute the patterns. I used clear gesso for the sample. Let it dry.

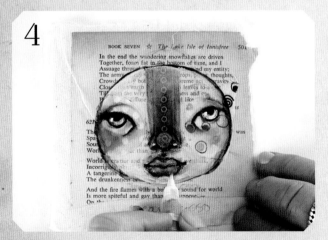

Paint the Face

Use a colored pencil to draw in the eyes, nose and mouth. Use watercolor pencil over the colored pencil, and blend with matte medium. Work back and forth between colored pencil and watercolor pencil until you are satisfied with the color. Use Titanium White or Titan Buff acrylic thinned with matte medium to add more highlights.

5

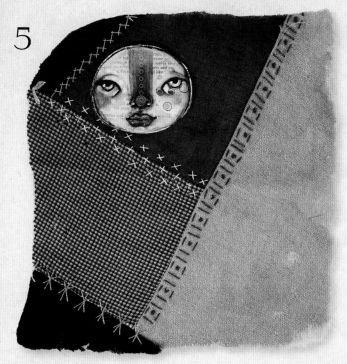

Cut and Place the Face

Cut out the face leaving about a ¼" (6mm) edge outside your pencil line. With the front layer of fabric right-side up, center the face about 1½" (4cm) down from the top edge.

6

Sew the Face to the Fabric

Pin the face to the right side of the fabric that will serve as the bear front. Machine or hand stitch the face to the fabric, using the pencil line as your guide.

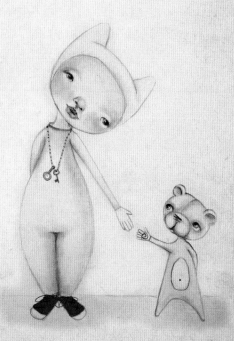

7

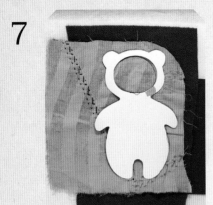

Trace the Bear Pattern

Place the front and back layers of fabric right sides together. Tape the area of the body pattern paper, where you cut out the face, back together. Lay the body pattern down so the face opening is lined up with the stitching line. Use a pencil to draw around the body pattern piece directly on the wrong side of the fabric. The pencil line will be your sewing line.

8

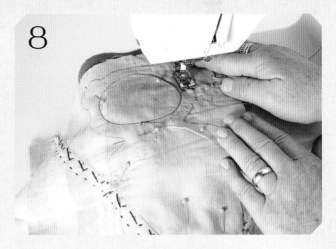

Pin and Sew

Pin the fabric pieces together. Sew by machine or hand on the pencil line, leaving the straight edge on one side open, as indicated on the pattern.

9

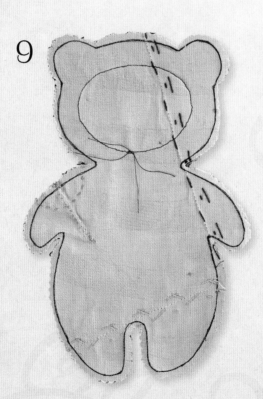

Trim the Fabric

Trim the edges down to ¼" (6mm). Make small cuts in the curves, toward the stitching line, so they stretch. Be careful not to cut through the stitching line. Alternatively, you can use pinking shears instead of scissors to trim the edges.

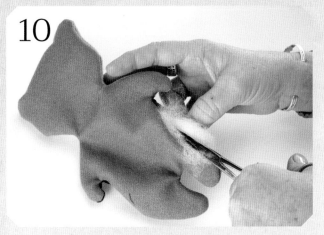

Stuff the Bear

Turn the fabric right-side out. Grab small pieces of polyester fiberfill, about the size of a golf ball, and stuff the bear firmly with a chopstick or stuffing tool. Using smaller pieces of stuffing will prevent your bear from being lumpy.

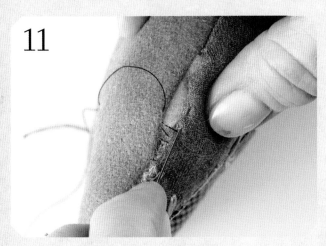

Sew the Bear Closed

Hand sew the open edge shut using a ladder stitch. You can add embroidery stitches, buttons or whatever inspires you to embellish your bear.

Making the Most of Your Patterns

I take my patterns to a copy store, copy them on cardstock and have them laminated. This allows me to use my patterns over and over. The crisp edge also ensures that the pattern you trace is more accurate. After the pieces are cut out, save the patterns in a plastic sheet protector. I keep all my patterns in a binder for easy access.

After cutting out the body pattern for the animal guide, I recommend saving the big piece that is left. Tape the area you cut through to unite the edges, forming a stencil of the actual bear pattern. When auditioning fabric, lay the stencil over the fabric so you can see which part of the fabric pattern you want to use.

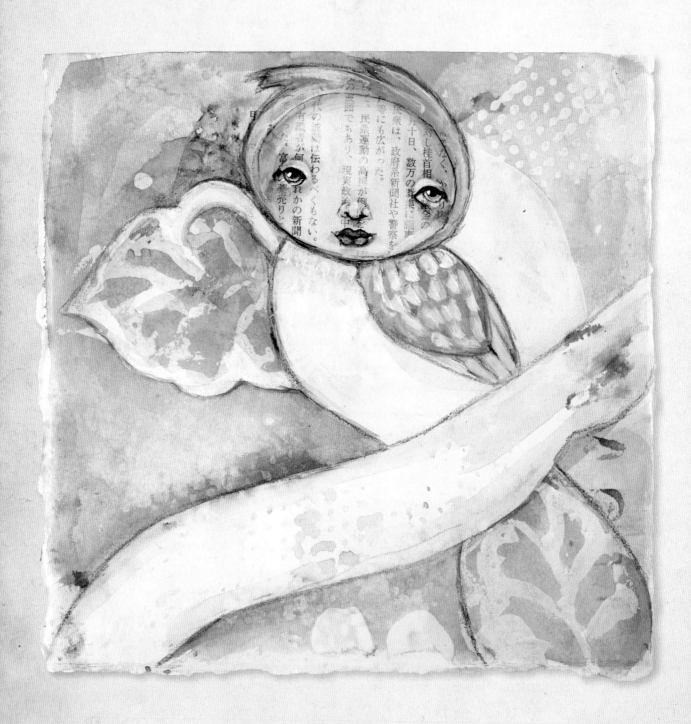

Magical Resistance
Matte Medium Resist–Inspired Figures

Most folktales take us to a time and place of magic and mystery, a land where woods are teaming with life, animals speak and the ability to fly is taken for granted. This project uses a resist technique to give life and gravity-defying movement to your characters. Methods that are spontaneous and unpredictable will result in amazing magical backgrounds and the building blocks to make unique characters. I love using resists because the outcome is always a surprise. By applying medium in sweeping strokes and using stamping tools that suggest body shapes, you are guaranteed magical results. My favorite stamping tools are jar lids, which can become faces, and foam stamps in the shapes of leaves, which can be bodies or wings. You can apply watercolor to the entire sheet or divide it into sizes you would like to work with and paint each one individually. The fun comes when the shapes are revealed. Turn the paper until you see a shape that suggests a body. If you are having difficulty visualizing the body, try placing one of the faces from your Character File on the paper and then move it around in search of the body.

Gather

¾" (19mm) flat brush

22" × 30" (56cm × 76cm) hot-pressed watercolor paper

Blending stump

Colored pencils

Faces from your Character File

Fluid matte medium

Graphite or mechanical pencil

Heavy body acrylic paint: white

Mark-making tools: your choice

Rubber and foam stamps

Ruler

Scissors

Spray bottle

Small round detail brushes

Texture stamps: shelf liner, jar or bottle lids

Watercolor pan set

Watercolor pencils: Derwent Inktense Bright Blue, Poppy Red

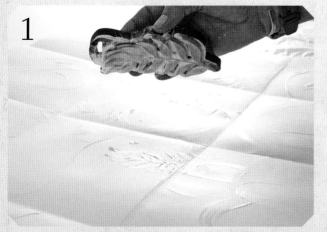

Fold and Stamp the Paper

1 Decide what size your final pieces will be and mark the measurements along the edges. Loosely fold the watercolor paper into sections that become a grid when you reopen the paper. Don't tear it into pieces yet. Working with the large paper intact will result in more expressive marks. The rough grid will ensure you make marks on every piece. My sample was folded in quarters, giving me sixteen 5½" × 7½" (14cm × 19cm) pieces.

Load a flat, wide paintbrush with matte medium, and brush in a sweeping motion to make swirls and circles randomly on the paper. Paint matte medium on a foam stamp and stamp the paper, then repeat with a texture stamp and jar lid. Let this dry.

2

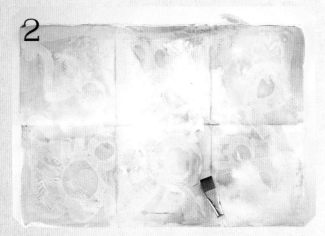

Add Background Color

Spray the watercolor paper with water. Then brush on watercolor to reveal the patterns.

3

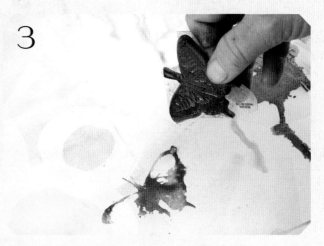

Stamp Accents

Paint concentrated watercolor onto stamps or other texture items, and stamp with an accent color. Tilt the paper for drips. Let dry, then tear the paper into sections based on your fold lines.

4

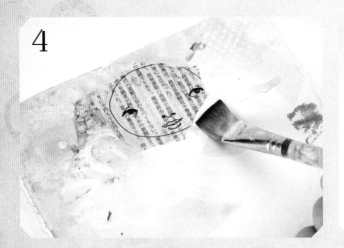

Adhere the Face

Search each torn piece for inspirational body shapes created by the resist. Turn the paper and get some distance if you are having trouble seeing a shape you like. Use matte medium to glue one of your faces on the background where you see a body shape.

5

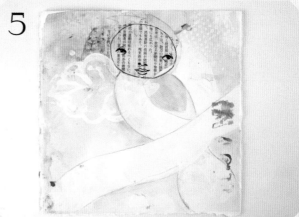

Start Defining the Figure

Outline the face and the facial features with a dark watercolor pencil and use matte medium to feather the lines out and to create shading. Use existing resist marks as the body. Colored pencil can be used to correct or darken lines on your original drawing. White paint can be used to cover up distracting elements and to add highlights.

6

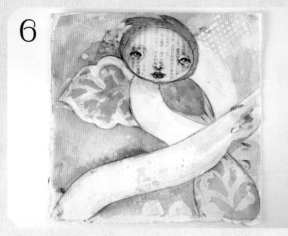

Add More Color

To add color in smaller areas, scribble a watercolor pencil onto your palette and pick up the color with a brush loaded with medium. This will prevent the hard edges and lines that sometimes occur when you apply pencil directly to the surface. Work back and forth with the watercolor pencil, adding shading and highlights until you are satisfied. Make sure to let each layer dry between applications. The process of working back and forth usually takes two to three passes before it looks complete.

7

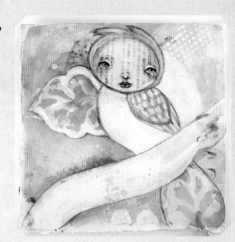

Final Details

Finish building up the layers of color and shading. Then use collage, pencils, pens or other mark-making tools to add final accents to the character.

Make It a Journal

If you want to make a journal, tear the large piece of paper in half on the long edge and then tear each half piece into three pieces along the long edge. This will give you six two-page spreads or folios that can be nested together at the end of the project and made into a book.

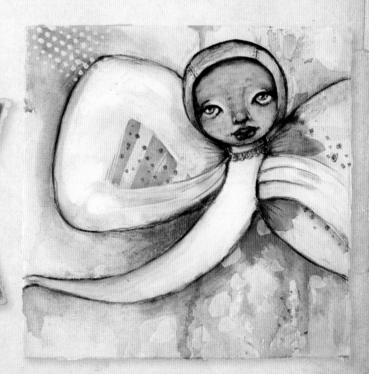

MYSTIFYING
PICTURES

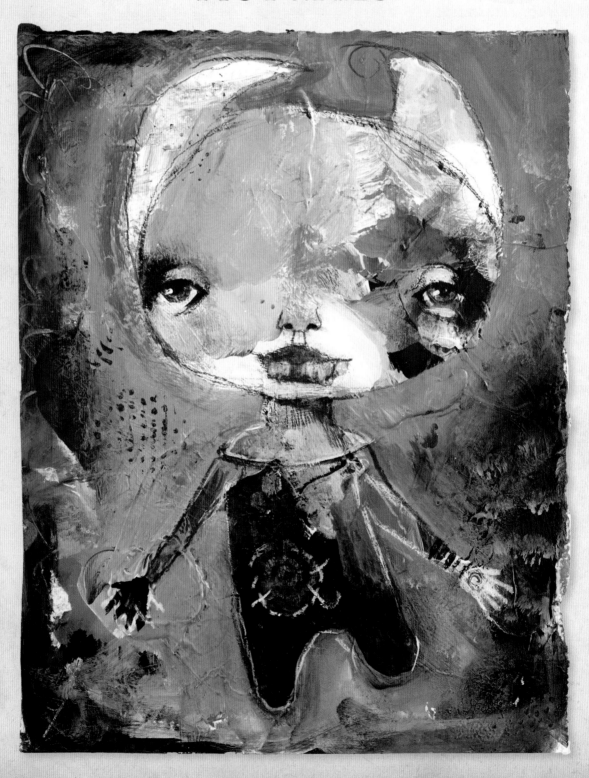

Characters Rising
From Ink and Paint

When I think of the word *mystifying*, I think of famous magicians whose sleight of hand causes us to utter, "How did they do that?" I am inspired by art that elicits the same surprise and wonder. The spark that encourages us to try to figure out how the results were accomplished and what inspired their ideas is what drives us on our quest.

This chapter is not just about ink and paint. It is about the practice of being present and paying attention to your intuition. I call it magical painting. It results in art that has mystery and heart. Your characters will rise from the canvas like magic.

Making expressive and varied marks and embracing mistakes and unexpected results are the foundation to making art that is uniquely yours. I follow an intuitive approach to find my characters. I'm always looking at my surfaces from different perspectives, eager to see that shape that says "paint me." Many of the exercises in this chapter will help you develop the ability to see more creatively, but keep in mind, they do require that you let go of your control and just follow your instincts!

Our Tale

As a parting gift, the Master gave the girl a special charm, a heart locket. He said it would help on the next part of her quest. Her magic key opened the locket, and she became aware of what the next step on her quest would be. She would seek the ability to create from her heart. She traveled on and found herself in the land of Mystifying Pictures. In this land, she learned to slow down, observe and enjoy the feeling of creating. She stopped worrying about how things would turn out and, honestly, made quite a mess. She started to glimpse shapes in the mess, figures that were begging to emerge. At this point she knew she had found the magic of trusting her feelings and poured her heart into her new creations.

Chapter Treasure

Observe.
Be present and let go of the outcome.
Embrace imperfection.
Trust your intuition.

"The key is to trust your heart to move where your unique talents can flourish. This old world will really spin when work becomes a joyous expression of the soul."

Al Sacharov

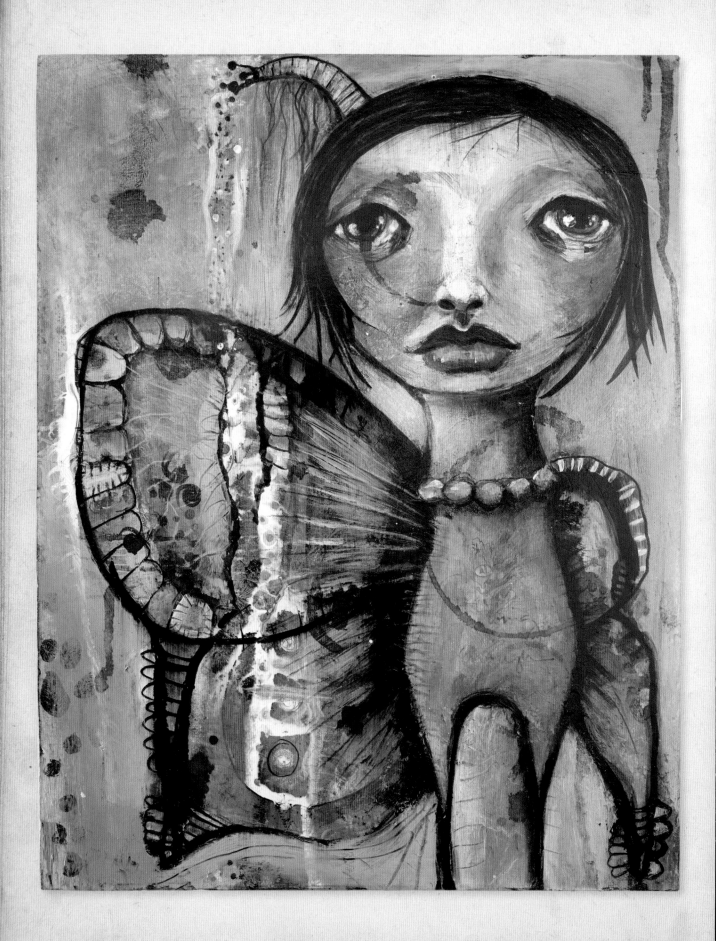

CREATING SOMETHING OUT OF NOTHING

My Tips for Magical Painting

Painting without a plan helps you to learn by doing, adjusting your goal from outcome to *moment*. It teaches you to pay attention to what you are doing and provides opportunities for experimentation, new experiences and techniques. Alternating between multiple pieces allows you to take a break from each piece and notice what is happening. Changing directions and making decisions is easier because there is no plan. You are teaching yourself to embrace your actions instead of fighting with your expectation of what it should look like. If you change your mind-set and expect less, you end up getting more than you could imagine. Mistakes become happy accidents and lessons to be learned. Techniques and approaches that are stress-free and fun allow you to relax and change your mind when needed. Over time you develop a style and practice that is your own. Here are some of my favorite tips for painting without a plan:

» Get some distance. Step back from your surface.

» Take photos of your work-in-progress. I use my phone camera, since it is with me all the time. Taking photos also forces you to stop and really see what you are doing.

» Breathe and take time to look at the painting. Do you see anything that suggests the next step, color or shape?

» Turn your surface to see if there are other possibilities. Is there an area you do not like? Cover it up with paint or collage.

» Using a discarded mat to isolate areas will help with your decisions.

» Place tracing or deli paper over your surface and look at your painting through it. The veil helps mute distracting elements and can help you see your shapes better.

» A clear acrylic sheet can also be used as an overlay to draw new shapes, block out distracting areas or try out colors without working directly on the surface.

» Observe and allow yourself to be influenced by what is happening and the interactions of paint, marks and shapes.

» If you see something to work with, start to define the area with drawing, shading and paint.

» Go slow, make small adjustments. Then re-evaluate.

» Ask yourself: Is there variation in marks, color, shapes, light and dark?

The most important concept is to be present during the creation process. It will be easier to let go of the outcome.

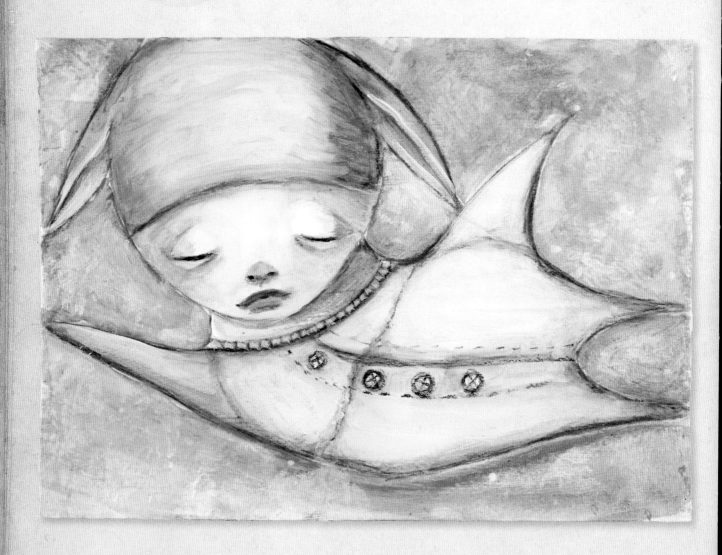

"The painter should not paint what he
sees, but what will be seen."

Paul Klee

Finding Figures in Random Shapes
Three Lines and a Circle

This is a quick exercise to practice creating without knowing the outcome. By starting a drawing or painting with random lines and shapes, you will give yourself a chance to warm up and get into your creative mind without expectations. The second portion of the exercise is about the practice of what I call "shape seeking," which is simply looking at your marks and visualizing possibilities. Consider the relationships between the shapes. Close your eyes and reopen them. What is the first thing you think of when you look? What you are doing at that moment is changing your perception, visually separating a figure from the background. It is up to you to determine what this will be. The sweeping lines of the exercise result in expressive characters with movement. The more you practice, the more you see. Save these exercises in your Character File for future inspiration.

Gather

¾" (19mm) flat brush

5" × 7" (13cm × 18cm) watercolor paper

Fluid matte medium

Small round detail brush

Watercolor pan set

Watercolor pencils: Derwent Inktense Payne's Gray, Poppy Red

Optional: mark-making tools, white gouache or acrylic paint

1

Seal the Paper With Matte Medium
Use a wide flat brush to coat the watercolor paper with matte medium. This coating will allow you to easily remove unwanted watercolor pencil lines.

2

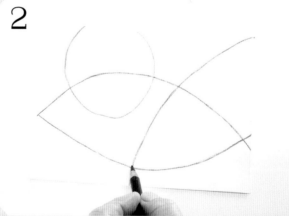

Draw a Circle and Three Lines
Make a circle and three lines with a watercolor pencil. Two of the three lines should cross at some point.

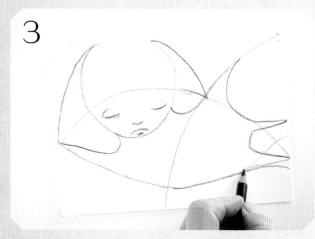

Find the Character

Look at your paper and think of the circle as a head, eye or body. Turn the paper and continue to look until you see a potential character. Use a watercolor pencil to draw the outline of your figure.

If nothing occurs to you, do another line combination. Don't toss the first one. Come back to it later; you may see it differently.

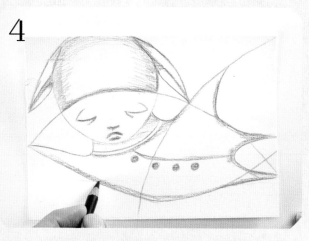

Define the Character

Use the watercolor pencil to darken the outline even more. Add more details and shading to further develop the character. Add personality with a hat and outfit.

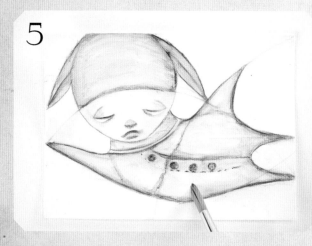

Blend the Pencil

Wet a round detail brush with matte medium and paint along the pencil line. Start moving the color into the center of your character, blending as you go. Use a brush loaded with water to lighten (or erase) lines you will not use.

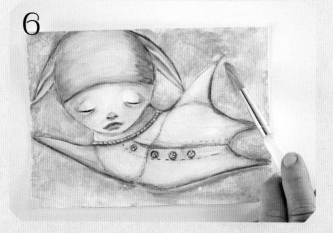

Final Details

Add more color with pencils and watercolor. In this example, I used watercolor pencil to add color to the cheeks and lips. Orange pan watercolor was used for the background to create contrast and move the figure forward.

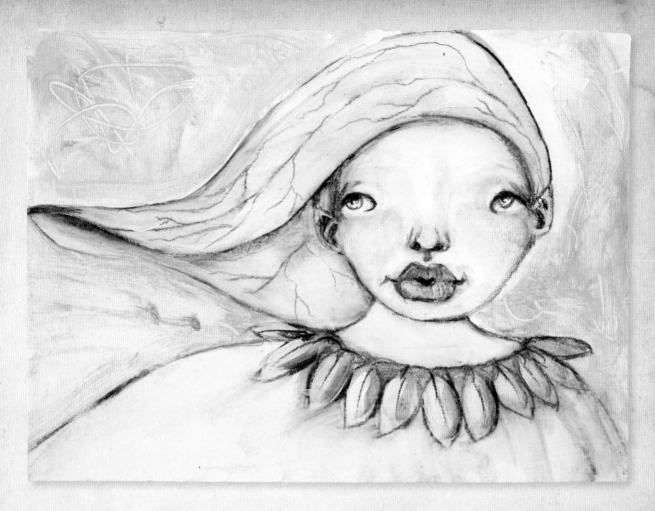

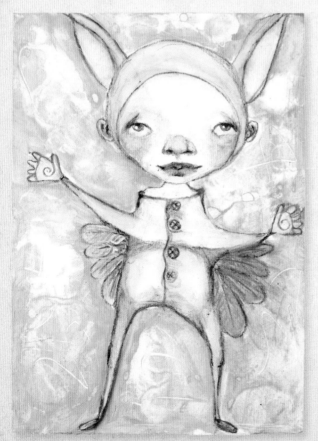

THINKING ON YOUR FEET
Mind Mapping to Generate Creative Ideas

I have been encouraging you to work on creating art without worrying about the outcome, but retreats, art exchanges, collaborative projects and charity events often start with a theme in mind. These kinds of challenges require thinking outside the box. I usually start with something called a "mind map." It is a visual way to brainstorm ideas and try to come up with something unique. In 2014, I participated in Carla Sonheim's *Year of the Fairy Tale* online class. One of the assignments was to illustrate *The Princess and the Pea*. In the story, a pea was placed under many mattresses to test whether the girl was sensitive enough to feel it, thus proving she was a princess. The challenge posed was, "What if it was something other than a pea?" I have included a sample of my mind map and how I arrived at my final drawing.

A mind map starts with a main idea and is surrounded by connected branches of related ideas. By writing down uncensored random words and ideas and seeing them collectively, you can generate creative ideas and unique connections. This technique works great for problem solving in life as well as art! Pick a topic you would like to illustrate. Here are some simple steps to get you started:

>> Use a large blank piece of paper. I use a 18" × 24" (46cm × 61cm) newsprint pad.

>> Start in the center of your paper. This will be the focus of your thinking. Your topic should be no more than a few words or a visual representation. Keep it simple.

>> Use free association to start your ideas flowing. Allow your thoughts to jump around freely.

>> Record what comes to mind. As you generate thoughts, draw branches from the main topic. Keep words to a minimum and continue to branch off as ideas flow.

>> If you get stuck, ask, "Who, what, where, when and how?" to generate ideas.

>> Try using one color pen for the first pass and change to a different color when you go through the process a second time so you can see your progress and changes more easily.

>> Once you have your thoughts down, see if there are groups of ideas that can be combined. Doing so makes it easier to see patterns.

Once Upon A Time...

Objects
pea bed ladder
mattress=leaves
moss
mushrooms?

Topic
Princess and the Pea
What if the "pea" was a **woodland pixie**?
Princess or **Fairy**?

Characters
prince KING
princess
woodland pixie?

Themes
proving worthiness

Settings
castle bedroom
forest?

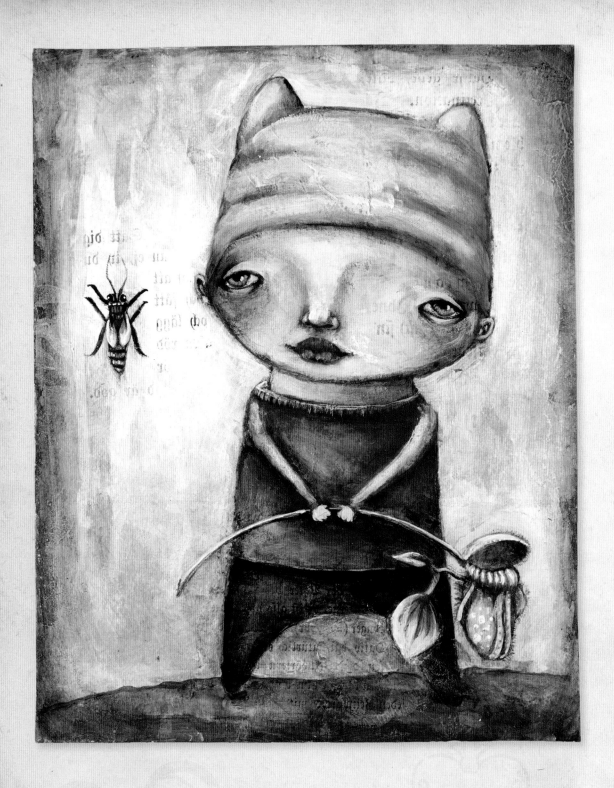

"Read the folklore masters. Go to galleries. Walk in the woods. That's what you need to be an artist or storyteller."

Terri Windling

Enchanted Illustration
Painting With Fluid Acrylics

Let's set off into unknown woods on our quest to create our own modern folktale character. Think of the background as a setting, waiting for you to add a heroine or tell a story. Pick your favorite classic folktale or fairy tale, maybe a story or poem from childhood for inspiration, a story that makes you want to put your paints to work.

Play with mind mapping to generate ideas about the look of your character. Think about style, colors, accessories, settings and companions. Sketch several simple versions of your ideas on newsprint the same size as your finished substrate. Make your drawing as large as you can. Try to fill the space. Do rough sketches, putting in only the most important characteristics: head, eyes, nose, mouth and body. You can add more details later with paint and collage. I use pencil to transfer my images because it is easy to correct lines and clean up on the painting surface. Lines made with carbon paper–type products can smear and are difficult to remove. Exercise patience as you layer the color on. Remember that letting each layer dry is the most important part of the painting process. If you know you have difficulty waiting for paint to dry, work on several pieces at once.

Gather

¾" (19mm) flat brush

6B graphite pencil

Acrylic craft paint: Neon Red, Pure Orange, White

Ballpoint

Blotter paper

Bristol paper or watercolor paper

Fluid matte medium

Gesso: white

Golden Fluid Acrylics: Titanium White, Titan Buff, Transparent Yellow Iron Oxide, Transparent Red Iron Oxide, Phthalo Turquoise, Quinacridone Red, Mars Black

Golden Soft Gel Medium

Heavy body acrylic paint: Titanium White, Titan Buff

Kneaded eraser

Newsprint

Permanent marker pen: black

Plastic card or scraper

Rag

Small round detail brushes

Toner copies of black-and-white clip art and text

Tracing paper

Watercolor pencils

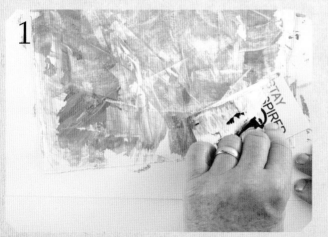

1

Paint the Background

Drop white paint onto your surface. Add one to two drops of the craft paint colors. Use a plastic card or scraper to mix and spread the paint on the surface. Do not overwork the paint. Carve into the wet paint to add texture, then blot with a blotter paper to pick up the excess.

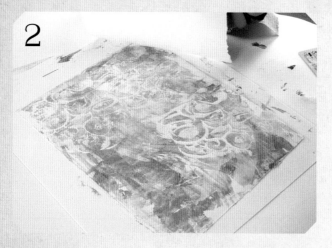

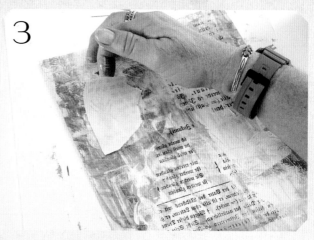

Add Texture

Put a few drops of white paint onto the blotter paper and use your finger to create a unique design. Reverse the paper onto your surface and pull up the paper, which now has the image on it. Continue to "print" your surface until all the paint is gone or you are pleased with the results. Alternatively, you can use foam stamps or household texture items painted with white paint.

Apply the Transfers

Select a toner copy of text or an image. The transfer will read backwards on your surface. If this is a concern, use the mirror function on the copier to reverse the text. I used German text for the example and chose not to reverse it. Apply a thin, even coat of soft gel medium to your copy surface. Place the copy facedown and burnish with a plastic card or scraper, being careful not to get medium on the top surface of the paper.

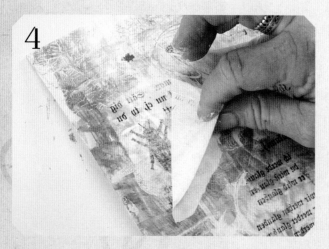

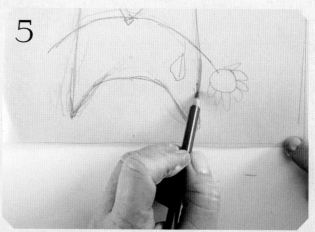

Reveal the Transfers

Wait a few minutes before you begin to pull off the paper. If the gel is too wet, the transfer will begin to pull up. In that case, wait another few minutes and come back to it. For stubborn areas, gently rub the surface in a circular motion with damp fingers to remove the residual paper. This technique will add further interest to your painted background without covering up your painted surface. It is worth the effort!

Sketch the Character

Draw your character by starting with a face shape. Look at your Character File, use an inspiration photo or draw one from your imagination. Sketch in the body. This can be as simple as a geometric shape or just lines connecting the head to a shape. Keep it simple. My bodies are usually about two heads high. If you have an additional character or element, rough that in. Now is the time to figure out location and shape.

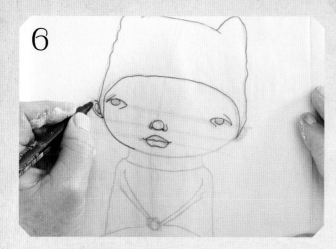

Draw the Character on Tracing Paper

Pick your favorite sketch and place tracing paper over it. Draw the basic lines of your character with a permanent ink pen, which will allow you to see the lines when you are ready to transfer the image to your surface.

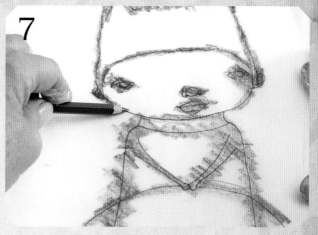

Prepare the Transfer

Flip the tracing paper over and cover the back side of the figure with a soft 6B graphite pencil. Hold the pencil on its side parallel to the paper. You don't need to cover the entire page, but make sure there is graphite anywhere you'll want a line to transfer.

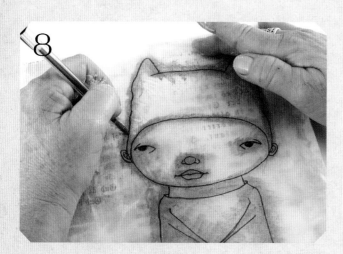

Transfer the Character

Place the traced image over your substrate and tape down one edge where you want the character to go. Draw over the lines with a ballpoint pen, pressing firmly on the page. This will transfer the image onto your surface.

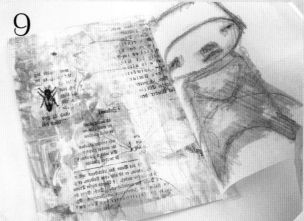

Clean Up the Transfer

Clean up any excess graphite that may have transferred to the surface with a kneaded eraser. Use a dark watercolor pencil to go over the lines of the drawing and add pencil in areas that will be shaded.

Visit createmixedmedia.com/
imaginary-characters to discover bonus art

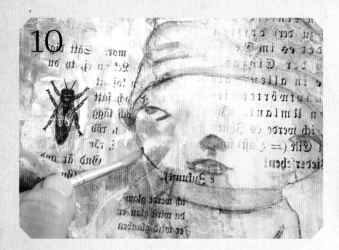

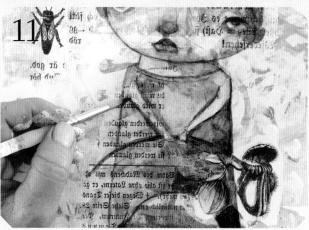

Add Shading

Use a brush loaded with matte medium to soften the pencil lines and feather the color into the center. Repeat this process using fluid acrylic and gel medium as a second layer, adding more depth and shading. Add in highlights with white or buff heavy body paint, and let dry.

Add Color

Dip a damp brush into the fluid acrylic paint and apply it to the surface. Use matte medium to move the paint. Water will decrease the vibrant colors and dull the finish. Start to add thin layers of color, letting each layer dry before adding the next. I also added the collage element of a flower, applying paint in the same manner as the figure.

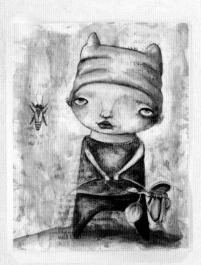

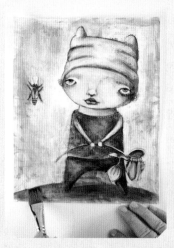

Build Up the Layers

Work back and forth between shading, color and highlights until you are satisfied with the colors. Empty your brush randomly in areas of the background as you are adding color to the figure. This will help tie the figure to the background. Add glazing layers until the background is unified. If the figure is not prominent, add white or buff heavy body paint along the edges of the figure, blending out toward the background. Feather the edges with a damp rag. Glaze over the highlighted area lightly to unify the piece.

Final Details

Glaze around the edge of the surface and blend with a damp rag, framing the piece and giving it an old fairy tale–book feel.

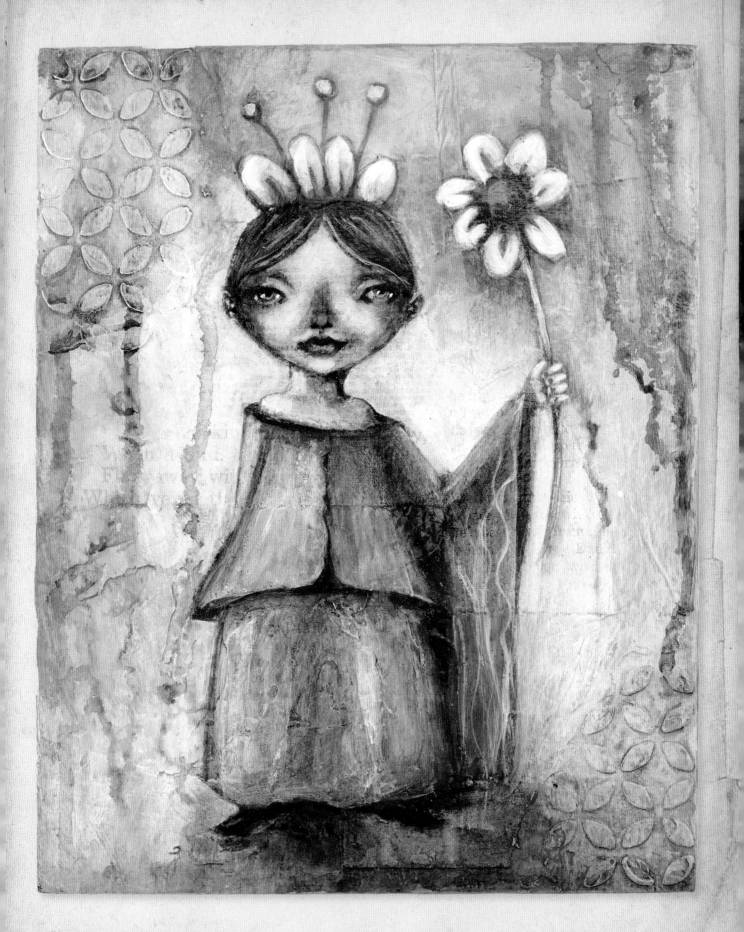

Good and Wicked
Positive and Negative Shape Painting
With Blooming Alcohol

Alcohol dropped into wet paint acts as a resist and pushes the paint away in patterns that look like blooming flowers. As a warm-up, you can create several quick backgrounds at a time and have them ready to use. Once the pieces have air-dried, you will need to exercise your shape-seeking skills to look for a figure shape. I almost always see some sort of butterfly or winged shape in the resist backgrounds. This is another opportunity to practice shifting your artistic perception. Find the figure, which is the positive shape, and become aware of the space that surrounds it. That is the negative shape, which shares the same edges as your figure. Think of negative shape painting like carving a sculpture. You will be using paint to carve away everything except for the figure. The value of this technique is to keep the complex marks and patterns you just created as your focal point, using opaque paint to mute everything else and bring your figure front and center.

Gather

¾" (19mm) flat brush

Eyedropper

Gesso: white

Graphite or mechanical pencil

Heavy body acrylic paint: Prussian Blue, Titanium White

Isopropyl alcohol 70–90%

Large mop-style brush

Mark-making tools: your choice

Plastic cup

Tracing or deli paper

Watercolor paper

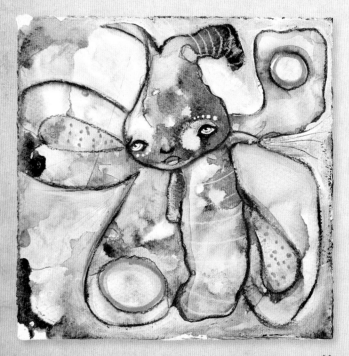

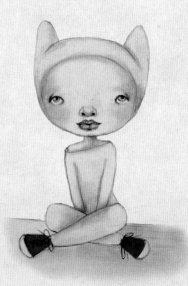

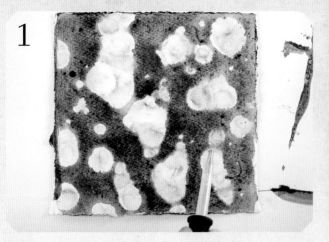

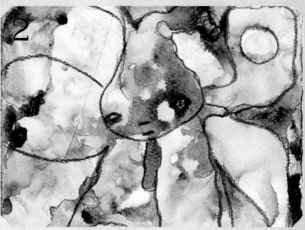

Create the Background

Before you begin, paint the watercolor paper with white gesso. The gesso will allow the acrylic paint to float on the surface.

Add paint to your palette and add enough water to make the paint loose and juicy. Use the mop brush and drip, flick and dab wet paint onto the paper.

Fill an eyedropper with alcohol and drip it onto the wet surface. Watch the paint separate into blooms. If your paint is not blooming, it is probably not wet enough. Let it dry, then reapply paint in a contrasting color and splash with alcohol. Put the piece aside to air-dry. Do not use a hair dryer, as it will destroy the bloom marks.

Find the Character

Look at the dry painted surface. Do you see any shape or character that is created by the paint? You can use a piece of tracing or deli paper to overlay your paper and play with the shapes you see using a pencil. Once you've found shapes that work for you, draw a line around them with a watercolor pencil.

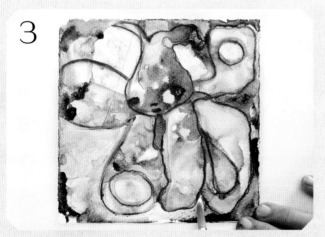

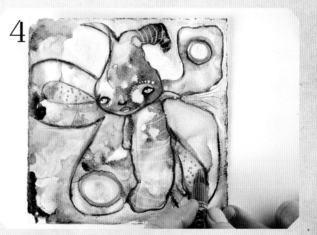

Develop the Character

Select a contrasting color and paint out everything except the character shape, leaving the interior with the alcohol texture untouched. In the example, I used white paint to mute the dark blue. You can carve into the wet paint for added texture, or overlay a stencil and remove some paint with a wet cloth or baby wipe.

Final Details

Finish the details on the face and interior shape with pens, pencils or paint. Alternatively, you can glue down a face from your Character File and integrate it using pencils and paint. I used white and pink acrylic paint pens to add the final details.

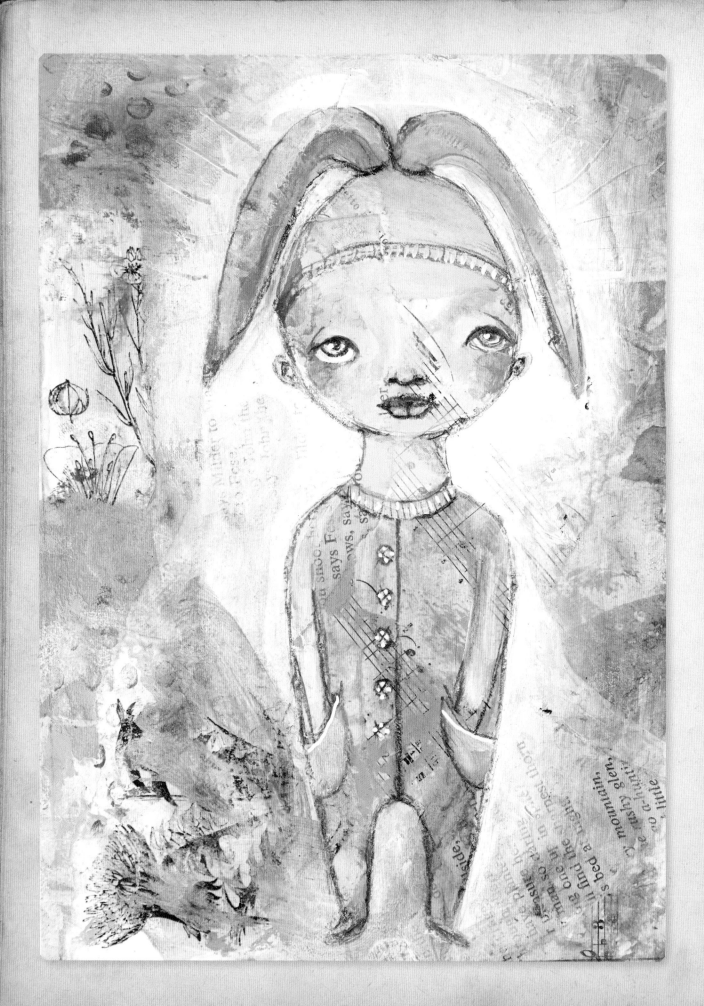

Using Masks and Stencils

Stencils and masks are like a magic trick. They can make things appear and disappear. The mask, or positive shape, hides what lies beneath it. The stencil, or negative shape, hides everything except the positive shape. Your choice to apply paint around the mask or in the open stencil area will dictate what appears. I primarily use stencils and masks to create unusual body shapes. I look for interesting shapes in unexpected places. Magazine photographs of art dolls, sculptures and fashion models are great sources for unusual shapes. You can tear a page out of a magazine or print an image from the Internet and create your stencil and mask. Photocopying or scanning images allows you to alter the size to fit your project. I also make my own stencils and masks by drawing a design on cardstock and putting it between two sheets of clear contact paper before I cut it out. The contact paper will protect the design and allow for repeated use. I save my stencils and the masks together in plastic sheet protectors.

Gather

Cardstock or blank index cards

Clear contact paper (optional)

Graphite or mechanical pencil

Heavy body acrylic paint: color that contrasts to the background

Magazine images of interesting shapes

Prepared background to work on

Scissors

Tape

1

Draw the Figure

Draw a simple silhouette shape on cardstock. Leave enough paper around the shape so that when you cut it out, you can add a little tape to make a complete stencil.

2

Cut Out the Figure

Cut out the mask and tape the stencil back together so it is one continuous piece.

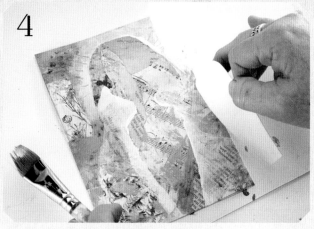

Paint Around the Mask

Place the mask over a premade background. Apply a contrasting color paint in a circular motion from the edge of the mask outward. Blend the edges or completely cover the background. Do not add water to the paint; it will leak under the mask.

Remove the Mask

Remove the mask to reveal your character shape.

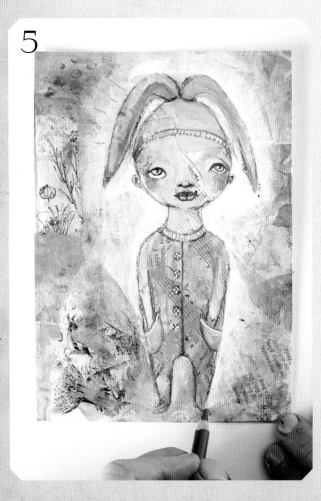

Develop the Figure

Draw in a face or collage a face from your Character File. Use pencils, pens and paint to add more details and develop the character you created with the mask.

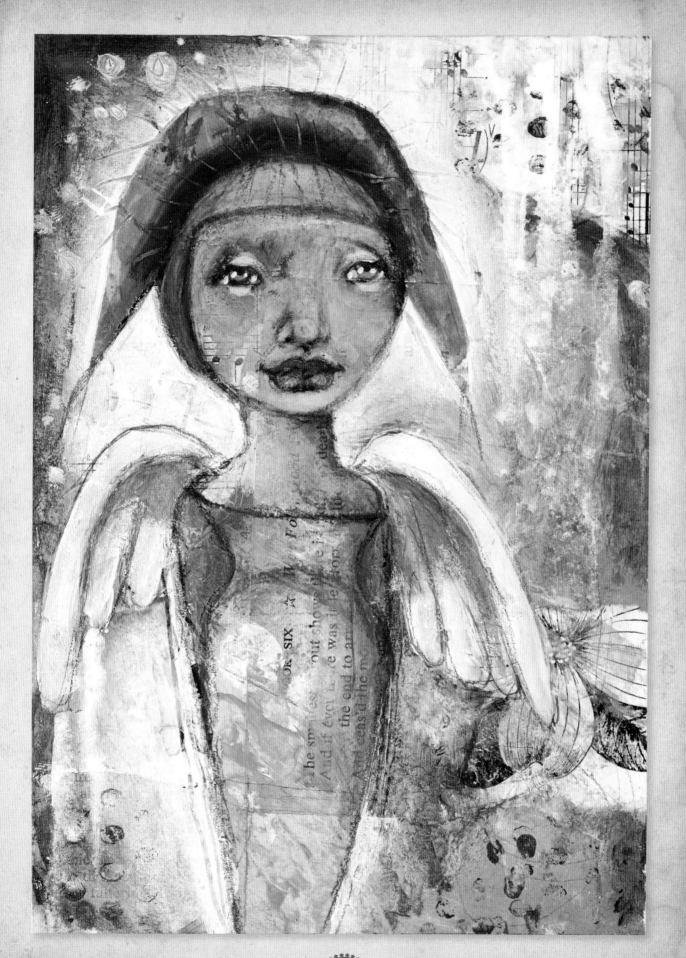

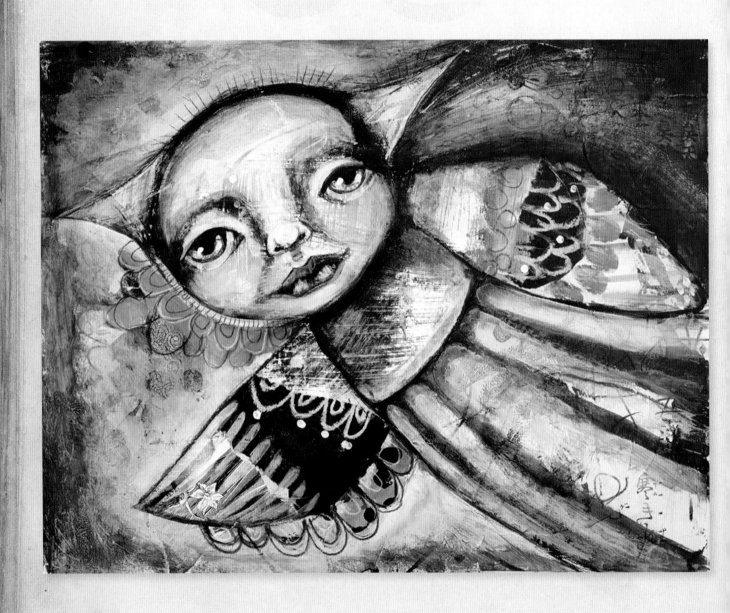

Visit createmixedmedia.com/
imaginary-characters to discover bonus art

Black-and-White Magic
Painting Without a Plan

A magician is skilled at performing tricks to make seemingly impossible things happen. Isn't making art like that? A blank surface or a lump of clay can be transformed into something completely different. Our creativity is our magic, and our skills are the magical props that help us produce the transformation. Black and white, dark and light, have a power all their own. The human eye is immediately drawn to a light element against a dark element. Likewise, the contrast of light and dark is what draws you to the focal point of a painting. To create the illusion of depth and dimension, gradations of value are also used.

This project is a continuation of our exploration of value from chapter 1. We played with black, white and gray briefly to open our eyes to the impact of creating contrast. We will take it a step further in this three-part magical process. The first task is to let go of any plan and discover the capabilities of your tools. Use them in nontraditional ways and see what happens. The second task is to observe the relationship between the light and dark, at the same time creating a rich, varied, complex ground. The third task is to use your shape-seeking skills to find your character.

Gather

Acrylic paint: black, white
Acrylic paint pen: white
Bamboo skewer
Bristol or hot-pressed watercolor paper
Blotter paper: your choice
Colored pencils: black, white
Deli or tracing paper
Fluid matte medium
Graphite or mechanical pencil
Newsprint
Oil pastel: white
Paintbrushes: flat, round, fan, bristle
Plastic card or scraper
Plastic palette knife
Toner copies of black-and-white clip art and text
Wax pastels or crayons: black, white

Collage and Draw the Background
Use a pencil, paint, collage and mark-making tools to create an interesting background. Don't go in with a plan; just start making marks and see what develops.

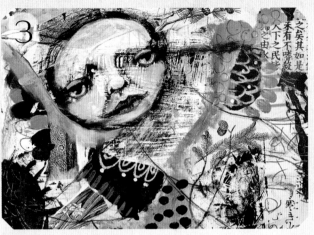

Continue Adding Texture

Use a pencil or crayon to add more texture marks and shapes to work with. Slow down and look at the surface. Divide the paper into quarters in your mind and begin to work in one of the quadrants by adding more marks and doodles. Concentrate on areas that are flat or mostly painted. Use your existing collage and marks to create repeat patterns and to connect or extend collage pieces. When you feel you have added enough, look at the paper. Get some distance. See if there is a suggestion of a shape already. Try laying a piece of deli paper on top and use a pencil to outline the shapes that you see for your figure.

Find the Figure

Draw your figure using a watercolor pencil. Develop the features in the face. Use white heavy body paint to block out distracting marks and blend into shaded areas. Add white highlights with a fairly dry brush.

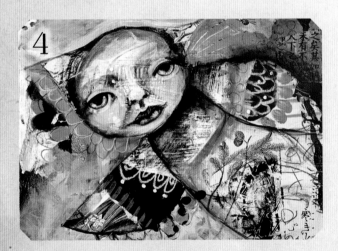

Refine the Figure

Choose whatever tool speaks to you and start working around the interior of the figure. Connect lines, add textures and step back. Make small adjustments and evaluate. Add more collage, if needed, to extend your character or tell a story. If you do not want to draw the face, one of the faces from your Character File can be glued down. Coat it with matte medium to protect it, then work over the top of it with your pencils.

Inserting a Character

If no character shape rises from the paper, use a piece of newsprint sized to your paper and make a mask/stencil. Draw a simple silhouette like a butterfly, flower, body shape or leaf, and cut it out. Tape the edges of the stencil (outer) portion together and apply the shape to the surface. Adjust the open area to include the parts of the painting you want to keep.

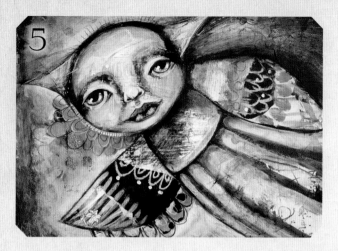

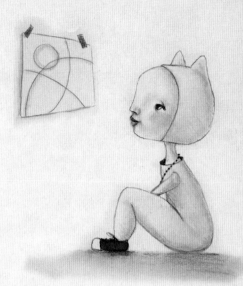

Final Details

Carve out your character using a contrasting paint mixture to block out the edges of the shape. Work slowly so the paint does not dry before you can blend it out. Adjust the paint value to contrast with the interior edge. You can pull the paint out to the edges of the paper or try "ghosting" the paint with your fingers or a rag so you can still view the marks. Carving marks into the wet paint can add a final touch.

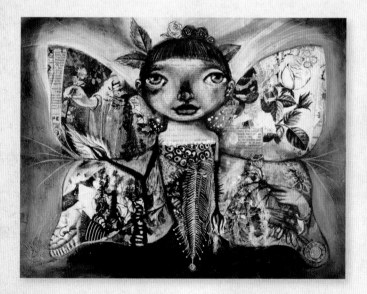

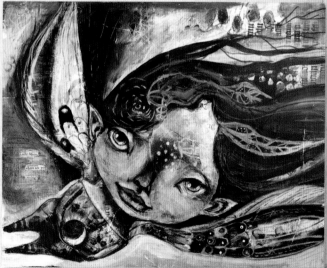

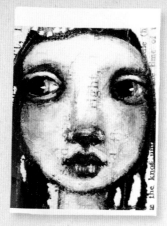

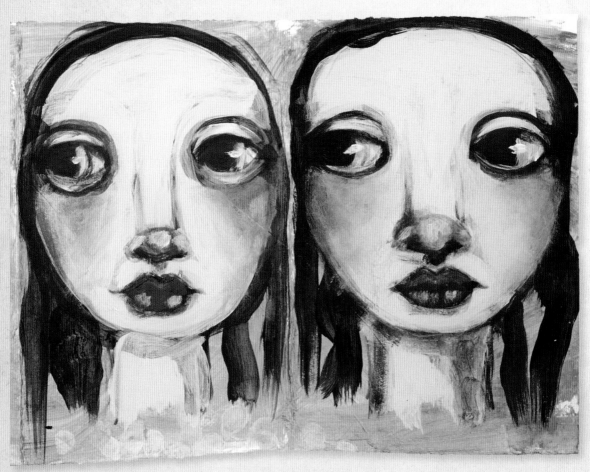

"If you hear a voice within you say,
'You cannot paint,' then by all means
paint and that voice will be silenced."

Vincent van Gogh

Painting With Abandon
Loose Acrylic Faces

I want you to experience the joy of painting with abandon—no pressure, no drawing, no planning, just pure color and self-expression. This exercise is about freeing you up, silencing that voice that says "I can't paint." It is all about doing—jumping right in and pushing paint around. Put on some music, stand up and move while you paint. Get some distance from the surface and let go! Take away some control by selecting the largest brushes you own. Try not to use your brush as a drawing tool. Thin your paint so it flows easily off your brush, then just "swish and flick." Magic will happen.

To evaluate your paintings, use discarded framing mats to isolate your pieces, or tape them up on a wall and step back. Ask yourself these questions: "What do I like? What bothers me?" Be specific. Look at color and value. Does the piece need adjustments? Save the paintings that fell short and try reworking them as a warm-up exercise. I promise that you will learn more from the paintings that fell short than from the ones that turned out great the first time.

Gather

Colored pencils

Gesso: white

Heavy body acrylic paint: orange, Quinacridone Red, Payne's Gray, Titan Buff, Titanium White, black

Hot-pressed watercolor paper 7" × 20" (18cm × 51cm) strip folded in four 5" × 7" (13cm × 18cm) sections.

Large round brush (I used nos. 10 and 12)

Plastic card or scraper

Reference or inspiration photograph

Small round detail brushes

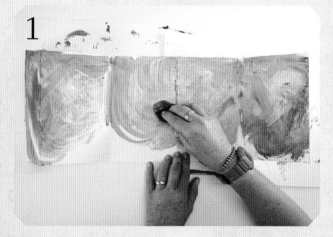

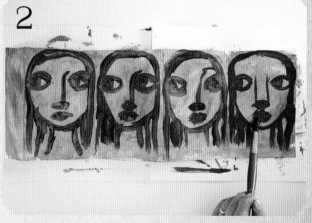

Paint the Background

Gesso the watercolor paper before you begin to seal the paper and allow the paint to float on top. Let it dry.

Squirt out a small amount of paint on the watercolor paper and spread it over the surface with a damp cloth. Select a middle-value paint for this as it will serve as the middle value in the painting. My favorite color to use is orange. The color peeks through and gives the painting a glow.

Paint the Base Layer

For the first pass, select a dark heavy body paint. Add enough water to make the paint flow off the brush easily. Look at your reference photo and determine where the darkest areas are located. With a large brush, paint the darkest areas on all four sections. Let it dry.

3

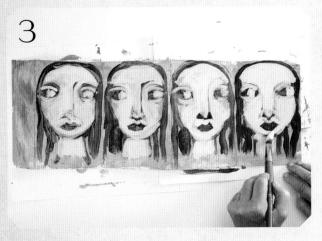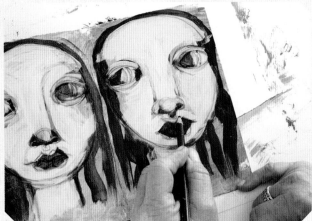

Add Highlights

For the second pass, look at your reference photo and locate the lightest areas, or the highlights. Remember, the toned paper is the middle value, so leave that exposed. Using your large brush and a thinned white or very light paint color, add in the light areas on all the paintings. Let it dry.

4

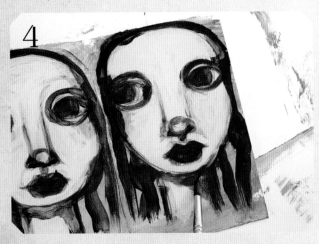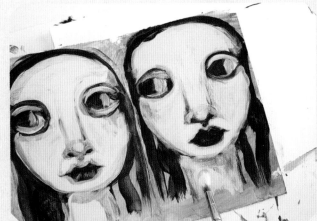

Add Shadows

For the third pass, look at your reference photo. Correct some of the lines with your colored pencils, if needed.

At this point, you can switch to a smaller brush. Add the darks and then the lights. Evaluate the paintings after the third pass.

5

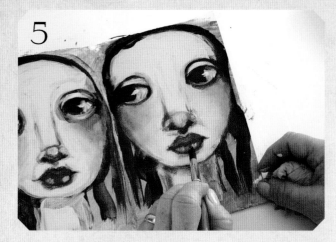

6

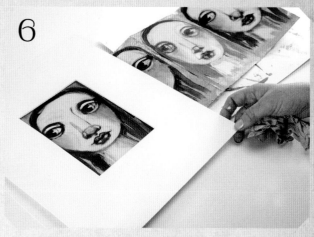

Add Texture and Details

Improve the picture by adding textures, blending colors, changing colors and adding shading and highlights. Remember, this is an exercise to loosen you up, so you can decide the painting is finished at any point.

Look at Each Individually

Use a white mat to isolate each painting. You will be surprised by how good they look.

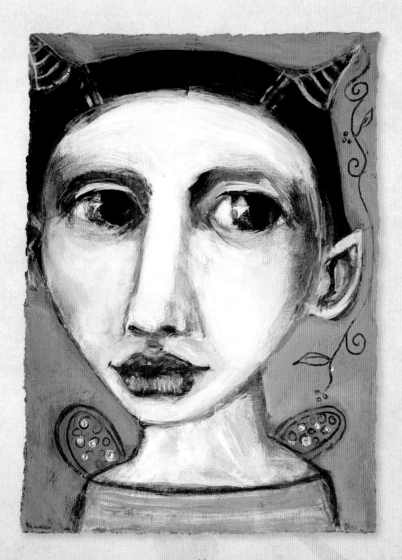

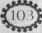

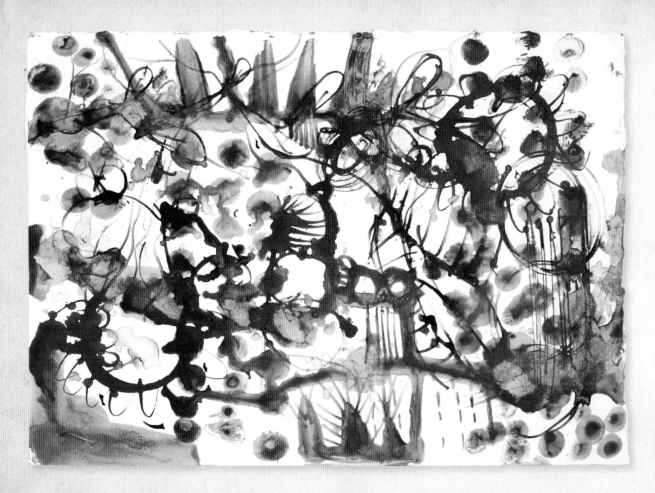

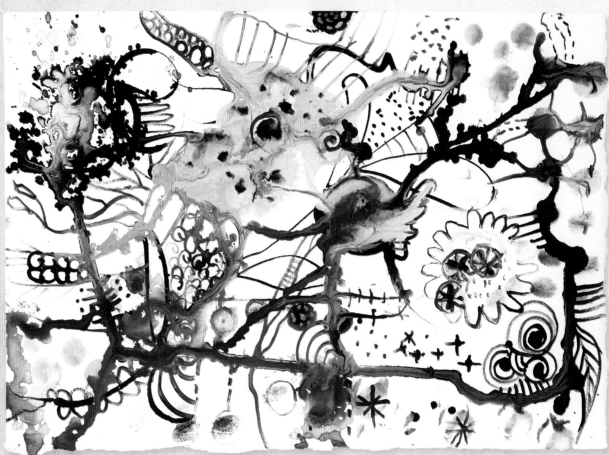

Acrylic Ink Play

I was first exposed to acrylic ink at the San Diego Comic-Con, an unlikely place to discover a new art supply. There is a section of the convention called "Artist's Alley" where aspiring comic book artists display their self-published books and often demonstrate their style. I watched an artist creating a character using acrylic ink. It glided on the paper beautifully, and the intensity of the colors was amazing. I ran to the nearest art supply store and bought some.

Take the time to play with new supplies. Experiments with color mixing, different mediums, surfaces and tools allow you to see what they can and cannot do. It is much better to learn these things before you are working on a special piece. Acrylic ink differs from other types of inks because it is waterproof. Once it is dry, you can work over the top without fear of bleeding colors. The following experiments are just the beginning of what you can do with acrylic ink. It can be used straight out of the bottle or watered down, like watercolor. I recommend you try using the ink with whatever materials and mediums you have in your studio.

Gather

¾" (19mm) flat brush

Bristol watercolor paper or journal

Daler-Rowney FW Acrylic Water Resistant Ink: red, yellow and blue

Fluid matte medium

Mark-making tools of your choice: bamboo skewer, stencils, sticks

Small round detail brush

Spray bottle

Exercise 1: Ink Color Mixing

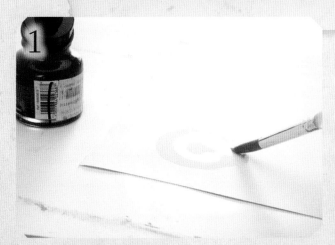

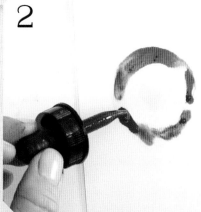

Add Water

Make a small dot with water and paint a circle around it with water. Leave a space between the two marks on the paper.

Add Color

Touch the tip of your red dropper to the outer circle. Use your wet brush to tease the red around the circle.

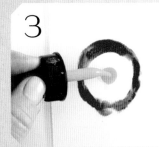
Add a Second Color

Using the dropper, place a drop of yellow ink in the center.

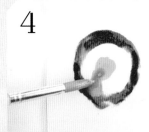
Spread and Mix

Tease the yellow into the red with your wet brush, observing the spread and mixing of the ink.

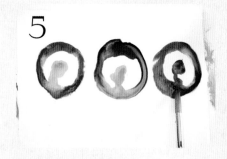
Experiment With Other Colors

Rinse your brush and repeat the technique with yellow and blue and red and blue.

Exercise 2: Ink and Water

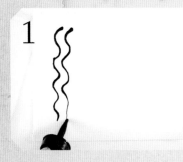
Add Ink to Dry Paper

Explore the way ink and water can interact. Using your dropper, draw lines with ink on dry paper.

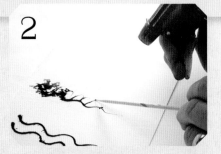
Spray Water on the Ink

Apply ink to dry paper with the dropper. Then spray the ink you just applied to the paper with water. See how it moves.

Spray Water and Add Ink

Spray the paper with water and drop the ink directly into it. The ink pools and spreads with the water.

Visit createmixedmedia.com/
imaginary-characters to discover bonus art

Exercise 3: Ink as a Glaze

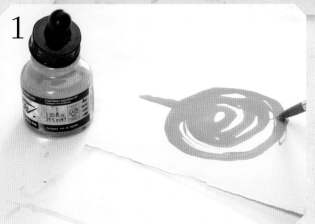

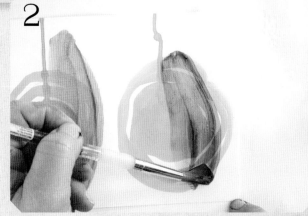

Paint Shapes

Paint shapes with ink and let dry.

Add Glaze

Mix a contrasting color with matte medium and glaze over the shapes. Try this with other colors.

Exercise 4: Mark Making With Ink

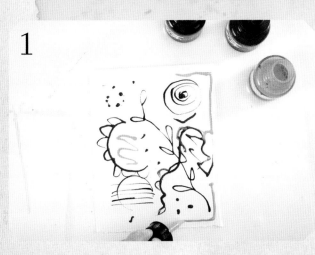

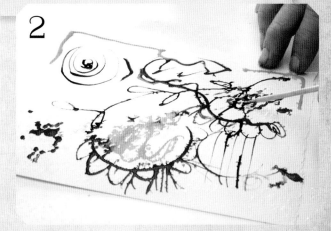

Add Inks

Apply red, yellow and blue ink to the paper, and use a variety of tools and your fingers to move the lines around, make marks and draw dots. Try this with black and white or other colors.

Make Marks

Continue playing with mark making. Be sure to screw your caps down to avoid spills. Have available all the tools you will need to play with the wet ink. My favorites are bamboo sticks, stencils, paper towels, brushes and wax crayons. Try to leave some white space. Be conservative with water to avoid all-over staining.

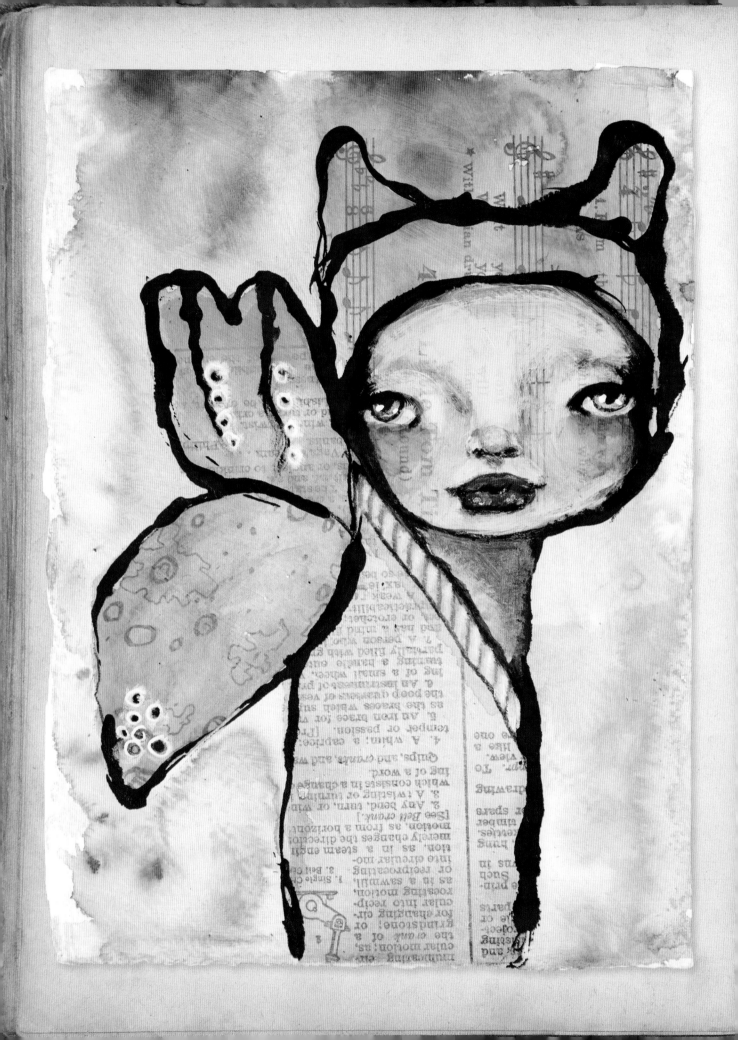

Acrylic Ink Drawing

Ink drawings can be a freeing starting point for a painting or journal page. Using a dropper as a drawing tool forces you to stay loose and expressive. I use the same inspiration sources for my ink figures as I do for my stencils and masks: dolls, sculpture, nature forms, fashion, even architecture. I capture unusual shapes in my sketchbook and collect images on Pinterest. When I get ready to do this ink-drawing technique, I gather some images and set them out to use as a visual reference. I tilt the paper and let the ink go wherever it wants to create marks I would not make on my own. This ensures I will have something fun and unusual to work with. The bold lines are dramatic.

This exercise uses a collage surface, which provides additional marks and interest. Coating the surface with absorbent ground allows you to use watercolors to finish the piece.

Gather

¾" (19mm) flat brush

5" × 7" (13cm × 18cm) Bristol or hot-pressed watercolor paper

Acrylic waterproof ink: black

Collage papers: old book pages, black-and-white clip art, torn coloring book pages

Colored pencils: black, white and colors of your choice

Fluid matte medium

Golden absorbent ground

Heavy body acrylic paint: Titanium White and black

Mark-making tools in black and white: permanent marking pens, acrylic paint pens

Paper towels

Plastic card or scraper

Small round detail brushes

Watercolor pan set

Watercolor pencil: black

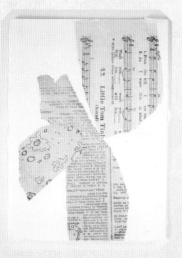

1

Collage the Background

Glue down three to four torn pieces of collage, dropped randomly on the surface. Coat the entire surface with absorbent ground and let dry. This will unify the surface and push the collage details back.

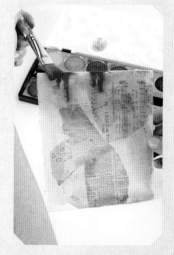

2

Add Color

Thin the watercolor paint with water. Scrape a flat brush loaded with the thinned paint across the top edge of the paper. Tilt the paper upright to get drips.

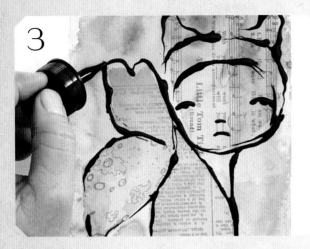

Sketch the Figure

Use an eyedropper with ink as your drawing tool. Draw a face and figure including only the basic elements: face shape, circles or dots for eyes, nose, mouth, neck and simple body shape.

Tilt your paper to let the ink drip a bit. The drips will add unusual lines to your figure. Blot the wettest spots with a paper towel and let dry.

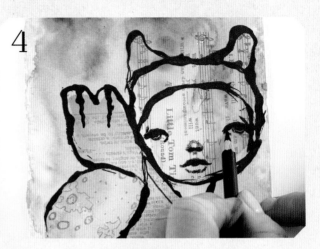

Refine the Figure

Add some white or black pencil to establish the eyes, depending on the background. You can use black colored pencil to reshape any feature. If you are unsure of where you want your lines to go, use a black watercolor pencil; the lines can be erased with a damp rag. The extra drip lines can lead to more interesting shapes or can be eliminated or altered with paint. I used them in this example to embellish the wings.

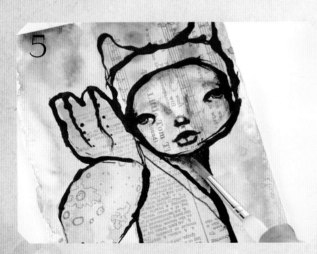

Add Shading

Add shading to the body and face with light applications of black pencil, ink or acrylic paint blended with matte medium.

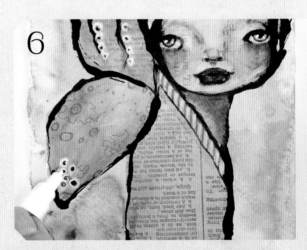

Final Details

Use white heavy body acrylic paint to cover up any unwanted lines. Try to leave as much of the ink as possible and define your shape with more black ink or pencil. Use washes of more watercolor to add depth. Add highlights with white acrylic paint. Use paint pens or other mark-making tools to add the final touches.

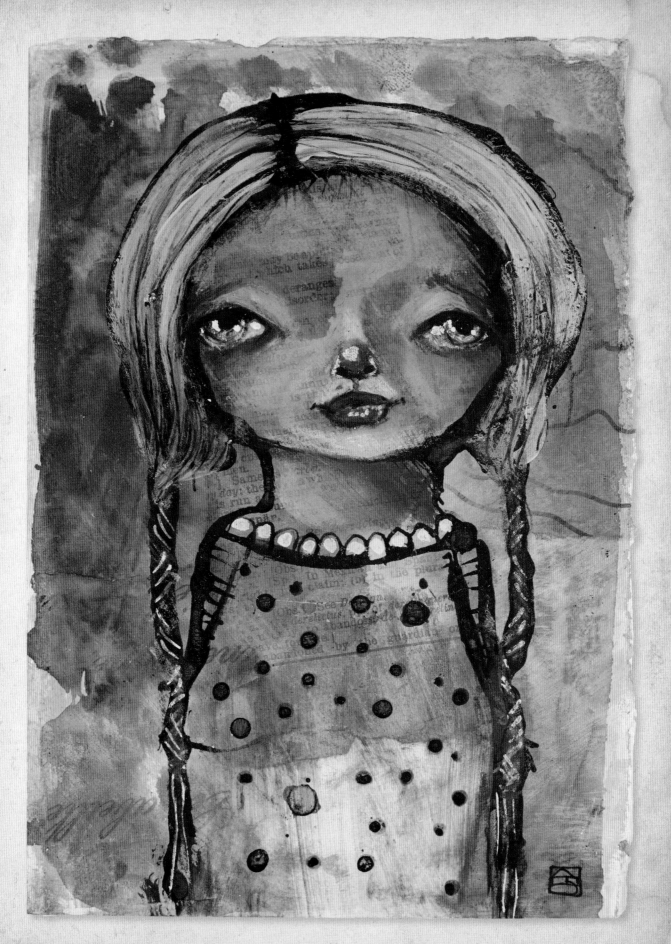

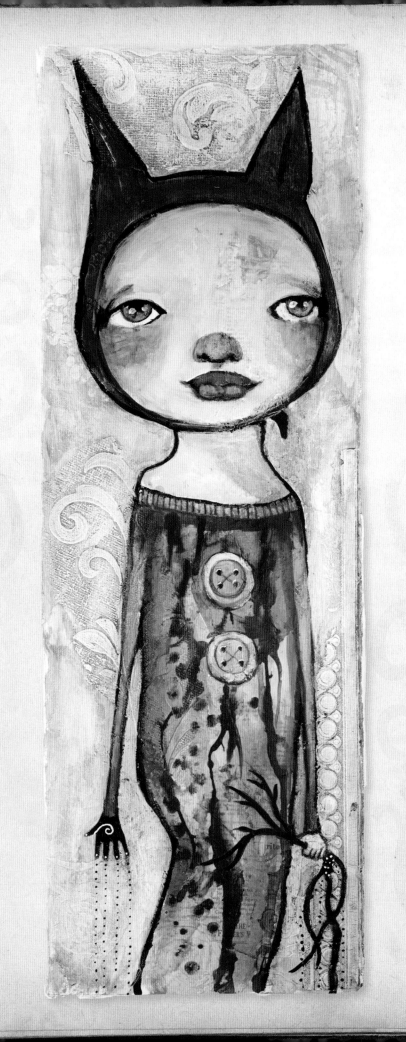

Urban Folk
Ink Figures on a Textured Background

This project began when I was asked to decorate the walls of a local theater for their next production. I was tasked with filling walls that were divided into large, long, narrow sections. It was a bit intimidating, and I wasn't sure if I could make enough art to cover the space, but I said yes and trusted that I would figure it out. To make the surface of my canvas interesting, I added texture with anaglypta wallpaper, gel transfers and stencils. Anaglypta wallpaper is a paintable textured wallpaper. It can be found at your local home improvement stores.

Once my texture elements were dry, I drew a character shape with my trusty ink dropper and, not thinking, picked it up before the ink was dry. The ink dripped everywhere and settled in strange ways into the texture areas. I decided not to panic and discovered that the drips gave me interesting marks to work with. I also figured out how to hide the marks that were not so interesting. It was the birth of what I call my "Urban Folk," and has turned out to be one of my favorite projects to do.

Gather
- ¾" (19mm) flat brush
- 7½" × 22" (18cm × 56cm) piece of hot-pressed watercolor paper
- Acrylic waterproof ink: black and 2–3 colors that work well together
- Anaglypta wallpaper border
- Colored pencil: black and white
- Fluid matte medium
- Heavy body acrylic paint: Titanium White and black
- Mark-making tools: permanent marking pens, acrylic paint pen, bamboo skewer
- Old magazine pages
- Plastic card or scraper
- Scissors
- Small round detail brushes
- Soft or regular gel medium: gloss
- Stencil
- Watercolor pencil: black
- White tissue paper

1

"We keep moving forward, opening new doors and doing new things, because we're curious, and curiosity keeps leading us down new paths."

Walt Disney

Collage the Background
Randomly collage torn pieces of textured wallpaper, tissue paper and textured paper with soft gel medium. It is difficult to paint over the heavy texture, so avoid areas where the critical face parts (eyes, nose, mouth) might be located.

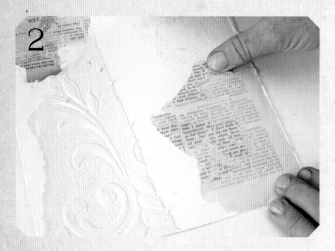

Add Vintage Paper

Select a piece of vintage magazine paper and apply a thin, even coat of gel medium to the side you want to transfer. Place the paper facedown and burnish it with a damp rag, being careful not to get medium on the top surface of the paper.

Wait for a minute or two and begin to remove the paper. Leave some paper on in places. This will give you the imperfect, torn look. If the paper is stubborn, gently rub the surface in a circular motion with damp fingers to remove the residual paper.

Add Stencils

Place a stencil on the surface and spread gel medium through the stencil with a flexible knife. Pick the stencil straight up to keep the pattern crisp. Do this step last so you do not smear the stencil image. Let everything dry. The gel medium may take a few hours.

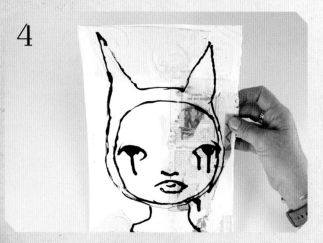

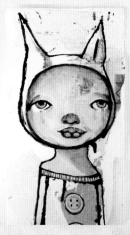

Sketch the Figure

Look at the surface to see if there is a suggestion of a figure shape made by the collage. If you are not seeing anything, use a reference photo or your imagination to create your character. Using black ink and the dropper, draw a simple face and body shape. Consider using your wrong hand if you want a looser character. Tilt the paper to get interesting drips. The ink will follow the texture lines. Let the ink dry.

Refine the Figure

Follow the steps in the Acrylic Ink Drawing exercise to refine your character. To maintain a loose, expressive piece, work with what you have without trying to modify the ink lines too much. Use pencils, paint pens, ink or paint to add details.

6

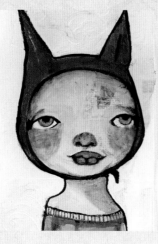

Add Color

Mix glazes using ink mixed with matte medium. Paint the glaze randomly over the area you want to unify, and blend the edges with a damp rag. Let each layer dry and apply a second color for added depth.

7

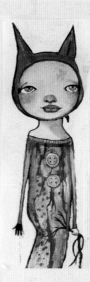

Build Up the Layers

Continue to build up the layers of colors, adding texture and visual interest with where you apply the glaze. Drip ink around the collar and spray with water to help it spread.

8

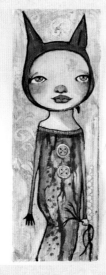

Bring Out the Background

Paint out the background with white paint. This will push the figure forward in the painting. Mix a glaze by adding a few drops of black ink to a pool of matte medium. Paint over the background, letting the glaze settle in the textured areas. Gently wipe the background with a damp rag, removing the glaze until you like the look. Once it is dry, use a stiff dry brush to lightly apply white paint to the raised areas.

9

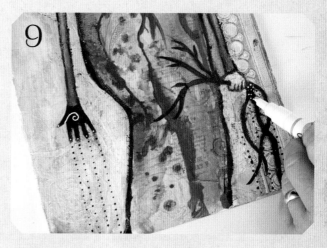

Final Details

Use acrylic paint pens, ink or other mark-making tools to add small details.

HAPPY ENDINGS AND BEGINNINGS

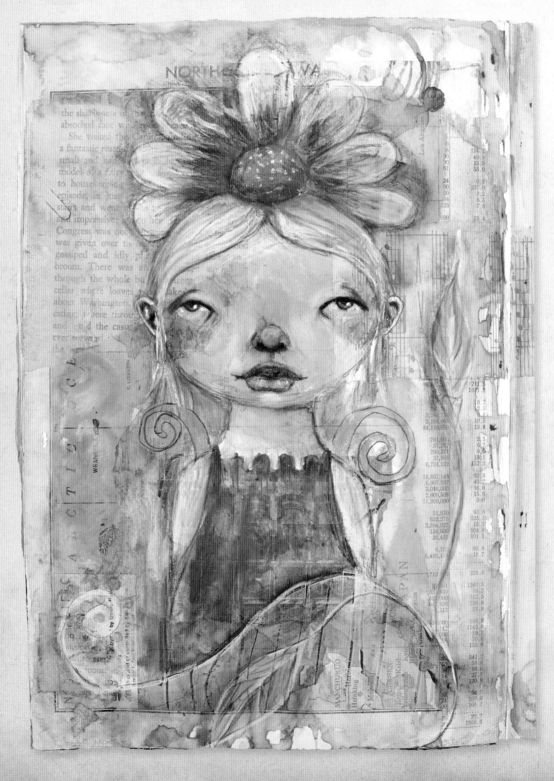

Continuing the Creative Quest

There is no ending on this quest for your unique creative self. I believe, in my heart and soul, that nothing can keep us from this lifelong exploration. It is part of who we are and who we will become.

The anticipation of learning something new, making it your own and sharing with others is essential to your quest. The challenge is to keep that desire alive. One way is to design your own educational path. It doesn't have to be a formal classroom education. The best teachers I have are my sketchbooks and art journals. They are portable containers for my ideas and inspirations. Keeping a working sketchbook allows you to record what inspires you, try out new tools and see what works and what doesn't. You can practice and play without worrying about outcomes. The biggest advantage to documenting your process in a book format is that it is "Your Story" as it develops.

You begin to develop your own style by your choices in subjects, colors, materials and their application. I recommend that you re-evaluate periodically, as your tastes and interests will evolve.

Sharing what you learn is an essential part of the quest too. It is not without risks to the ego, but it's important to learn to take constructive feedback with grace. Share your enthusiasm in conversations, give your creations to others, participate in an art exchange. Find or organize a local group to meet and create with on a regular basis. You will find yourselves sharing and teaching each other. Become what I call an "inspirationalist," a person who aims to inspire others.

Our Tale

The girl was energized by all she had learned on her dream travels and was ready to return home. Her determination to record her experiences and practice her new skills was strong. Perhaps she would create a journal that would be ready for travel wherever she chose to go. She added wings to her magic red shoes to help speed her on her way. She carried with her the treasure she had collected as reminders:

» The Key: to believe in the open door of possibilities.
» The Magnifying Glass: to focus on artful curiosity and the beauty of the details.
» The Spiral Hand: to grow in skills and confidence.
» The Heart Locket: to observe, be present and exercise intuition.
» Wings: to rise above challenges and seek a unique path.

Chapter Treasure

Rise.
Know how to travel light.
Play with renewed purpose.

memories

drift

Metamorphosis Art Journal

I thought it fitting for the last project in this book to be about the magic of transformation. I call this project the Metamorphosis Art Journal because you change the physical form and substance of an existing book into your own artistic playground. Having a safe place to experiment without judgment can be life changing. To make something just for the joy of it is an important aspect of life as a creative.

My approach to converting an old book into an art journal is to focus on preparing the pages so they can easily be finished using only my travel supplies. I believe that if you stick to simple tools, you are more likely to use the book to play. I prep, collage and paint some pages so they are ready to go when I am.

There are no blank pages in old books so less collage is needed to create a complex surface. An old book comes with a potential theme, based on its old life. I gravitate to children's books and those with maps that have an intact binding, books that are not too thick and are comfortable in my hand. This gives me a book that is easy to carry and that is realistic to finish.

Gather

¾" (19mm) flat brush
Bamboo skewer
Deli or wax paper
Fluid matte medium
Golden Absorbent Ground
Golden Soft Gel medium
Plastic card or scraper
Stamps: rubber, foam, shelf liner, jar lids
Travel supplies (see page 123)

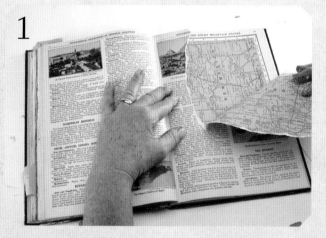

1

Tear Out Pages

Tear a page so that you leave intact a tab the full length of the book. Remove every third or fourth page to reduce the size of the book. This will keep it from getting too difficult to close after the addition of paint and collage. Save the book pages for your collage stash.

2

Add Gel Medium

Paint soft gel medium on one side of the tab you made. Smooth it onto a page from the spine toward the page edge using your plastic card. The tabs add strength to the book when glued to the adjoining page.

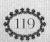

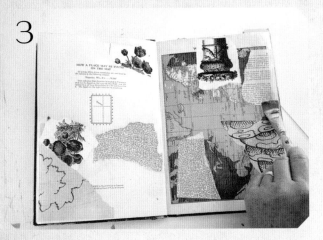

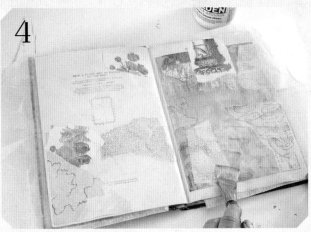

3

Add Collage

Grab any collage paper that inspires you. Brush fluid matte medium on the back of the piece and glue it down randomly. Cover it with deli or wax paper, and use a plastic card to burnish it down. Glue down about three pieces of paper per page, leaving some of the original book showing. This is a very freeing process. Give yourself permission to have fun and do not plan each page. Work the whole book. Jump around.

4

Prepare the Pages for Watercolor

Coat a spread of two collaged pages with absorbent ground. It will create a veiled unified look to the page and allow the non-absorbent collage papers to accept watercolor. Use painterly brushstrokes, and carve lines and patterns into the ground with the end of your brush. These marks will show when you add your watercolor layer. Let the pages dry. Place a sheet of deli or wax paper between the pages and close the book. Weight it down with something heavy overnight, and the pages will be completely flat in the morning. At this stage, the book is ready for travel.

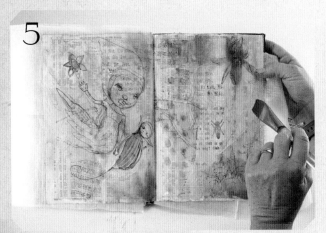

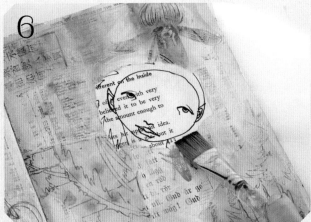

5

Add Watercolor

Mix up one or two pools of watercolor on your palette and apply randomly to a page. Tilt the book and let the paint drip.

6

Find a Figure

Flip through your book and look for a page that grabs your interest. Look for shapes created by the collage that could be heads or bodies. If your shape seeking doesn't work, select a face from your Character File. Trim as needed, apply fluid matte medium to the back of the paper and glue down on the page. Cover with wax or deli paper and use the plastic card to burnish any wrinkles.

7

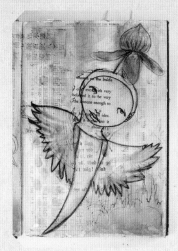

Draw the Figure

Using a watercolor pencil, draw a line around the edge of the face and add a simple neck and body. Use a small brush loaded with medium to feather the outline edges toward the center of the figure.

8

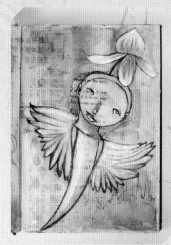

Develop the Figure

Evaluate existing collage elements to see if you can connect them to your figure using watercolor pencils. If there are no elements to connect to the figure, consider adding more collage. In the example, I incorporated the collage flower into her hat.

9

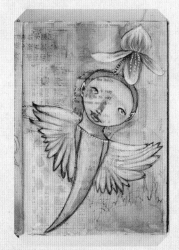

Add Highlights and Color

Use white heavy body acrylic and a round detail brush to highlight areas on and around the figure. Add color with pan watercolors and pencils.

10

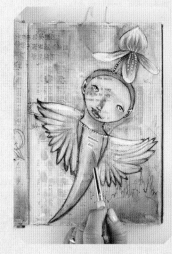

Final Details

Embellish the figure with pencils, pens and crayons until you feel it looks complete. This is the step where your personal style will shine. Cut out words from old books to enhance your page. Glue them down with medium.

Visit createmixedmedia.com/
imaginary-characters to discover bonus art

BECOMING AN INSPIRATIONALIST
Discovering Your Unique Style

It is an important part of the creative quest to take time to understand what influences and inspires you. This includes all aspects of your life, from clothing to home decor. Your style is the sum of your personal choices, a complex mixture evolving from your life experiences that makes your unique creative self. This self-knowledge will help you make better decisions in your art and life path. Admiring and imitating other artists is part of the learning process, but it is only a beginning. It is how you infuse your individuality into what you learn that counts. By understanding what influences you, communicating about what you create becomes more comfortable. When faced with the question, "Where do you get your ideas?" you will be able to answer easily, making it clear that those ideas are uniquely yours. Group your work together and look at it as a body of work.

» Are there repeating themes, symbols, color combinations?

» Which tools and materials make your heart sing when you are using them?

Ask yourself these questions:

» What do I want to create?

» Am I inspired to create what I see around me: nature, people, architecture, objects in the physical world—an external focus?

» Am I motivated to create by the ideas that come from my head and heart—an internal focus?

» Where do I find inspiration?

» What kind of things do I collect? Do they influence my art?

» If only I could paint like_____

» I really get in the creative zone when I am_____

I have found that most artists have strong feelings about the type of art they are drawn to create. Recognizing this can help you focus and make good decisions about supplies, classes you choose, groups you join and your best creative path.

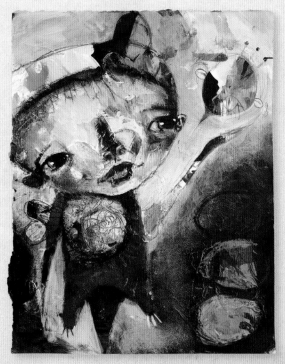

"We shall not cease from exploration
And the end of all our exploring
Will be to arrive where we started
And know the place for the first time."

**T.S. Eliot – "Little Gidding"
(the last of his Four Quartets)**

WAYS TO KEEP THE CREATIVE FLOW GOING

» Start a sketchbook
» Make an Inspiration File or Box. Fill it with anything that inspires you and use it when you are looking for a fresh idea.
» Take lots of photos, including ones that focus on the details.
» Give yourself a warm-up time to ease into the creative zone.
» Practice, practice, practice.
» Make a series of paintings on the same subject or theme.
» Give yourself permission to experiment and play.

» Have the supplies you need ready and within reach so you can stay in the creative flow.
» Work on multiple projects at once to keep from becoming overly focused on one piece.
» Step back often, and take pictures as you go.
» Use tools that will give you less control like sticks, eyedroppers, fat pencils and larger brushes.
» Be curious and keep asking "*What if?*"
» Participate in a collaborative project to stretch your creativity and gain experience with deadlines.
» Join an art group.
» Share what you learn!

TRAVEL SUPPLIES

Here are the supplies I recommend for your travel kit:
» 6B graphite pencil
» Acrylic ink in small container: black
» Acrylic paint pen: white
» Bamboo skewer
» Deli paper
» Eyedropper
» Glue stick
» Gouache paint: white
» Heavy body acrylic paint: Titanium White
» Mechanical pencil with eraser
» no. 6-8 round detail brush
» Oil pastel crayon: white
» Paper towels
» Pencil sharpener
» Permanent marker pens
» Selection of colored pencils
» Small container of fluid matte medium
» Small scissors
» Small selection of collage papers
» Stick eraser

» Texture stamps: small selection
» Travel-size baby wipes
» Water brush: large
» Watercolor pencils: black, blue, red (minimum)
» Watercolor travel pan set
» Wax pastel or crayons: black and white

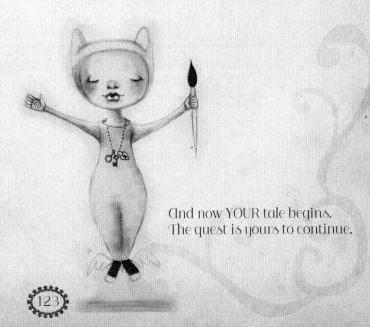

And now YOUR tale begins.
The quest is yours to continue.

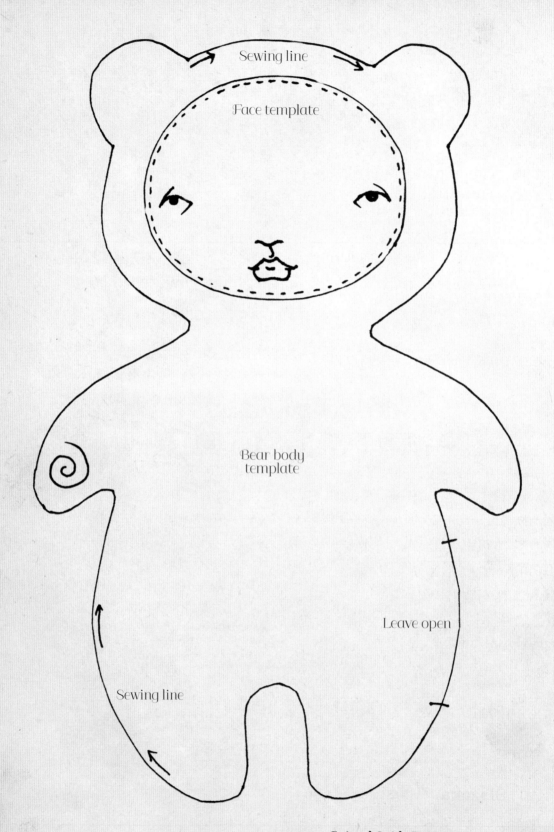

Sewing line

Face template

Bear body
template

Leave open

Sewing line

Animal Guide Pattern
Enlarge and print at 115%
You can also download a PDF at CreateMixedMedia.com/
ImaginaryCharacters

INDEX

Photography by Jennifer Butler

About the Author

Karen is a self-taught artist and teacher. Her creative journey began in the world of teddy bear and doll making and expanded into mixed-media painting. Karen uses whatever materials inspire her as she searches for her muse. She strives to convey a sense of empathy and harmony with her soulful, contemporary characters. Karen's artwork and articles have appeared in *Somerset Studio*, *Art Journaling* and *Art Doll Quarterly* magazines. She is a featured artist in *Incite: Color Passions* and *Incite: The Best of Mixed Media*, and she is a guest artist in *Drawing and Painting Imaginary Animals* by Carla Sonheim.

Her approach to teaching is "No mistakes, just dive in and see what happens." She believes in playful curiosity, learning to see and trusting the process. Karen teaches at her studio and at mixed-media workshops across the country. Her home and studio overlook the beautiful Applegate Valley in southern Oregon, where she creates in her magic red shoes.

"I am on a journey, exploring the path of intuitive art, listening to the voice within to learn, create and share what I find."

Her website has links to her art, blog and Facebook page at www.KEObrien.com.

a content + ecommerce company

Other fine North Light Books are available from your favorite bookstore, art supply store or online supplier. Visit our website at fwcommunity.com.

19 18 17 16 15 5 4 3 2 1

DISTRIBUTED IN CANADA BY FRASER DIRECT
100 Armstrong Avenue
Georgetown, ON, Canada L7G 5S4
Tel: (905) 877-4411

DISTRIBUTED IN THE U.K. AND EUROPE
BY F&W MEDIA INTERNATIONAL LTD
Brunel House, Forde Close, Newton Abbot, TQ12 4PU, UK
Tel: (+44) 1626 323200, Fax: (+44) 1626 323319
Email: enquiries@fwmedia.com

DISTRIBUTED IN AUSTRALIA BY CAPRICORN LINK
P.O. Box 704, S. Windsor NSW, 2756 Australia
Tel: (02) 4560-1600; Fax: (02) 4577 5288
Email: books@capricornlink.com.au

ISBN 13: 978-1-4403-4025-3

Edited by Beth Erikson
Designed by Elyse Schwanke
Production coordinated by Jennifer Bass

Metric Conversion Chart

To convert	to	multiply by
Inches	Centimeters	2.54
Centimeters	Inches	0.4
Feet	Centimeters	30.5
Centimeters	Feet	0.03
Yards	Meters	0.9
Meters	Yards	1.1

Dedication

This book is dedicated to the child in all of us.

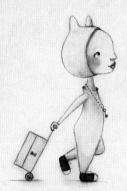

Acknowledgments

To my husband, Paul, for being my support, best friend, voice of reason, fixer of all things and "roadie." With your support, my dreams have become a reality.

To my students and friends who share in the Quest, for your enthusiasm and support. I continue to be overwhelmed and inspired by your willingness to jump in, trust and share your journey with me.

To Beth, my editor, who gently guided me through the complex world of publishing and was there, like a fairy godmother, just when I needed her.

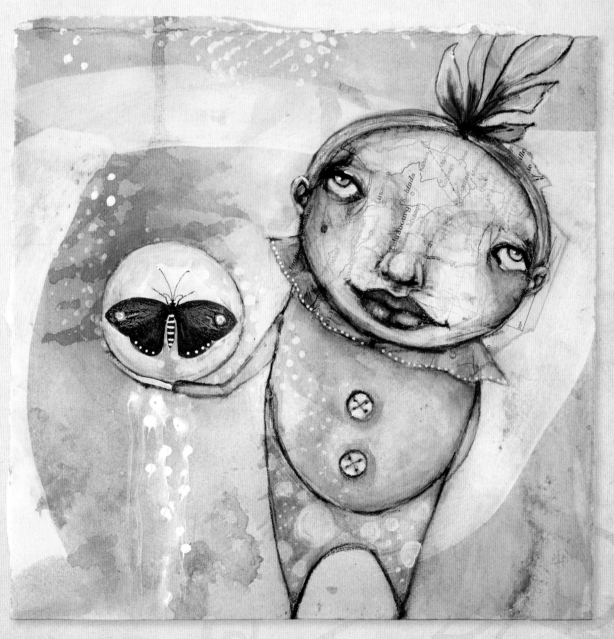

Ideas. Instruction. Inspiration.

Receive FREE downloadable bonus materials when you sign up for our free newsletter at artistsnetwork.com/Newsletter_Thanks.

Find the latest issues of *Cloth Paper Scissors* on newsstands, or visit artistsnetwork.com.

Get your art in print!

Visit **CreateMixedMedia.com** for up-to-date information on competitions.